ANIMAL ARCHITECTURE

INGO ARNDT

TEXT BY PROF. DR. JÜRGEN TAUTZ

FOREWORD Jim Brandenburg
PHOTO CAPTIONING Ingo Arndt
TRANSLATED FROM THE GERMAN BY Mary Harris and Henning Grentz

ANIMAL

ARCHITECTURE

INGO ARNDT

TEXT BY PROF. DR. JÜRGEN TAUTZ

Abrams, New York

FOREWORD *Jim Brandenburg*

Some photographers are perfectly in sync with their subject when visually bringing its story to life. Accomplished photographers have an individual style that has evolved from their strong point of view or the way they see the world through the camera lens after years of concentrated and deliberate work. I have seen the incredible possibilities that are created when there is a good pairing of subject and photographer. I have also seen the failure when there is a mismatch.

Ingo Arndt's photographs and this book's theme represent one of those ideal matches. I know few photographers who have both a deep passion and talent for being in the natural world as well as the eye and discipline to graphically illustrate such a complex subject as this one, all the while demonstrating the refinement and nuance of a studio photographer. In the past, I have been given this same kind of assignment and know very well the challenges at hand. The studio and the wild are two different worlds that require two totally different approaches. Two photographers are usually needed to complete a project such as this, with the result often being less than desirable. We can clearly see the advantage of Arndt's ability as we turn the pages of this book. The rhythm and graceful flow of the photographs allows us to seamlessly read the oftentimes chaotic complexity of the natural-world setting. The more illustrative studio work was done with one clear, visual voice, which only serves to add another layer to and deepen our experience. An extra and important gift is the book's elegant design by Ingo's talented wife, Silke Arndt. The "livability" of a

book like this is as dependent on design as are the animal dwellings shown here. The harmony of purpose of the team that created this volume speaks for itself.

Aside from studying the fine photographs taken for this book, I also happen to have a strong personal interest in the subject of man-made and animal architecture. Had I taken the correct turn in life, architecture is the profession I may have committed my life to instead of photography. I have thought long and hard about man's struggle to find wise solutions to the issue of sheltering himself from nature's elements. Two of man's shelter designs—the polar Inuit igloo and the Native American tepee—stand out for their simple and extremely effective but rare ability to function like many of the animal housing solutions in this book.

I have extensive experience with these two structures, having lived in both. Hundreds of these nomadic peoples' generations have perfected the ability of these shelters to be built quickly from local materials, for them to travel well, and for them to protect the family from the harshest conditions on earth. The same principles work for the animals in this book, and, ideally, can fulfill man's needs as well. Simply stated, "form follows function"—that's what drives evolution and creates these remarkable shapes and forms in the natural world. However, man's ego-driven desire to make a statement, plus his need for high levels of perceived comfort, make the differences between man-made and animal-made dwellings even greater. I have been caught up in that vortex myself.

A few years ago, I experienced firsthand the legendary industry of the beaver and the robust lodges that they construct. My task was to insert an infrared video camera into the inner space of a lodge that was located deep in the North American wilderness. The video signal was then to be transmitted to a satellite by way of complex technology to share with the world the secrets of a beaver family. On the surface, the lodges appear to be little more than a pile of tree branches. I soon found out how strong and nearly impenetrable those structures really are. After an exasperating effort to install the camera, I discovered the phenomenal drive that the beaver has to repair and maintain its home. Every day, the camera needed to be taken out of the lodge and the lens cleaned, as it was covered with mud and small sticks. Even though rare footage of beaver and muskrats living together in the same lodge was captured and sent around the globe, it finally became too exhausting and disrupting a task to keep up with the beaver's tireless house maintenance schedule!

All of the above took place in my "backyard," a million-acre wilderness that I call home on the American and Canadian border. Fourteen years ago, after having lived in a simple classic log cabin on the site for many years, I decided to expand my living space. I chose to work with an architect who had developed a style and feel for a more traditional yet novel and contemporary structure. His roots were born from a deep Finnish tradition in the architectural language set by the master Alvar Aalto. My goal was a modest one: to add a common sense amount of space to the cabin I had outgrown. I soon discovered the exhilaration of working with a true artist of his craft, and then spent the next five years drawing and redrawing the plans. When the construction finally began, the proposed simple "lean-to" became inbued with a genuine architectural personality. The home-studio went on to be awarded the top architectural award in the United States that year. The architect became famous, and I became a bit overwhelmed with all the attention, given my reclusive nature-photographer lifestyle. I was indeed proud, but architectural tours and media kept me on edge. Perhaps I should have followed my inner voice and those wise words that I preach: "form follows function."

I find the animal architecture examples in this book a good counterpoint to and a stark reminder of the human need to express beyond practicality. Animals have no ego or pride to drive their needs to an impractical and environmental compromise. Yet the designs and shapes they produce are as elegant and wondrous as any architecture man has ever built. My home is certainly not grand but it is more than I need. I am now ready to pass on my beloved abode to a worthy environmental group that can use it in a larger sense and justify its existence—a lesson learned and, as I look at this collection in *Animal Architecture*, confirmed.

Jim Brandenburg

INTRODUCTION

Creating a Legacy

Animal burrows, although the results of animal behaviors, can far outlast the life of the individual builders, and can tell us about the past in the same way that a fossil can. However, as long as they serve their builders or their successors, these structures also become a part of the history of the animals. The constructions extend the capabilities of their builders with astonishing results, and throughout this book, some of the most spectacular examples of these creations are presented.

Animal homes can be impressive and miraculous structures. We often marvel at the building materials used and the details of the architecture. What the constructions are used for is, in many cases, not immediately revealed—a mystery that can be solved only if we patiently observe how the creators of the objects make use of them. Regardless of which aspect it is that we admire about the animal constructions, in the end it always comes down to one question: How did this structure come to be? The great evolutionist Theodosius Dobzhansky (1900–1975) said aptly, "Nothing in biology makes sense, except in the light of evolution." This point of view hits the nail on the head,

and in part provides an explanation for the amazing achievements found in *Animal Architecture*.

The basic principles of evolution are easy to see when they concern adaptations that improve the chance of survival for living creatures. Camouflage makes it harder for animals to be found by their possible predators, and thus they are able to survive, unlike their fellow species that are less hidden from sight. But there are also features that some animals have that make them so conspicuous that they should actually become easy prey for predators. However, these creatures continue to remain alive and well—and they also still manage to reproduce very successfully and have their lineage carried on for generations to come. So the question we must ask is, what are the advantages of this apparently nonconformist phenomenon?

The English naturalists Charles Darwin (1809–1882) and Alfred Russel Wallace (1823–1913) were the first to find a logical answer to this question: The adaptations that serve the animals' survival originate from natural selection.

The environment of the wild ensures that individuals equipped with different skills will successfully reproduce in different ways. Those that are well adapted have a better chance of survival and, consequently, pass on their genotype to the next generation.

But what about those seemingly pointless qualities that can even be hindrances in extreme cases, such as the splendid tail feathers of the male peacock or the giant antlers of the elk? If you compile a list of such attributes, you'll find that only males harbor these traits. The explanation for this goes back again to Charles Darwin: Female animals select their mating partners based on the hereditary traits they would like to pass on to their offspring. Darwin called this "sexual selection." Which qualities the females find attractive depend on many factors and are often not easy to explain, even in individual cases. But the fact is, the females significantly determine the direction of evolution by the choice of their mates, and in this way ensure that certain male qualities and abilities assert themselves. Animal constructions are also part of natural and sexual selection.

Internal and External Worlds

The English biologist Richard Dawkins (born 1941) looked beyond the skin, fur, and plumage and came up with the concept of the "extended phenotype," which adds a completely new and exciting aspect to the consideration of environmental versus internal factors. Whereas "phenotype" traditionally denotes all physical characteristics of an animal, such as size and eye and fur color, the "extended" phenotype includes all the effects of genetic predispositions, thus also including behaviors.

Therefore, the boundaries between animals and their environment are not as clearly defined as the classic phenotype dictates. Through its actions and their lasting results, an animal affects more than just itself. In its entirety, the extended phenotype is also subjected to the selection process and includes the constructions created by an animal. The craftsmanship of the animal builder can make the difference between success and failure in the fight for survival and the passing on of genes in reproduction. Natural and sexual selections' combined complexity determines the outcome for the builder and the construction.

The Purpose of the Nest

What happens when animals actively shape their environment or parts of it? This refers to an active and specific design and not just a random act that occurs in the environment. An elephant that exerts an enormous physical influence on the four miniature slices of earth under its soles changes the land beneath its feet. In comparison, what is fundamentally different about the influence that a beaver dam has on its environment? An elephant's footprints don't play a role in the life of that elephant (at least, as long as they're not tracked by a hunter); they are the circumstantial results of the behavior of the pachyderm. However, a beaver dam has a purpose. It changes the environment of the builders to their advantage.

The characteristics and functions of an animal's organs bring up questions regarding functionality, causality, purpose, and, finally, the question of what type of animal it is. The animal's constructions bring up these same questions. For example, what is the purpose of nests, wherein do advantages for the builders lie, and what are the results of nests' construction? The benefits for nest builders are based on the nests' functions, and in fact nests often fulfill several purposes at once. They offer the animal architects protection against adverse environmental factors and provide miniature universes for optimal living conditions. Nests can also be used to communicate, and thereby connect the inhabitants together or outwardly provide signals that reveal something about the builder.

Location Is Important

Dwellings are rarely transportable. Among the exceptions are snail shells, the tubes of caddis fly larvae, and the chrysalides of the caterpillars of some small butterfly species. As a rule, an animal's nest has a fixed address. Some animals are completely sessile, or attached to a base (such as tube worms and corals). Others, such as birds, can move freely. Such freedom comes with a price, however, and places considerable demands on these animals. They must develop skills that stationary creatures don't need to have, especially the ability to orient themselves in an often very complex and considerably vast landscape. The nest inhabitants must find their home after an excursion,

and not through a time-consuming search, but rather through a highly targeted one. This homing ability is based on sensory powers and an amazing spatial memory that is almost unimaginable to us humans.

Some nests are built by an individual animal, while others are created through the coordinated interaction of a group of animals. The building materials that are used—which can come from the animal's own body or can be exogenous—are precisely arranged with the foot, beak, or mouth and, in certain cases, are physiochemically processed so ingeniously that they would stand up to the high-tech methods of an industrial building materials manufacturer.

It is rarely the animal architects alone that benefit from their constructions; there are also many other users, whether they serve as roommates during the builders' lifetime or take over their structures long after the builders are gone. Mites inhabit beehives, hermit crabs move into empty snail shells, a large number of living creatures benefit from the hydro-architecture of beavers, and coral reefs are used as building materials by humans. Also of note, the principle of sustainability applies to animal constructions. They are usually used over many generations, are always environmentally friendly, and are even biodegradable.

In the long run, will humanity be as successful with its "nests" as the animal architects presented here?

THE
PURPOSE
DETERMINES
THE
STRUCTURE

THE DIVERSITY OF BIRDS' NESTS IS DUE PRIMARILY TO BIRDS' VARYING SIZES AND THE DIFFERENT BUILDING MATERIALS USED

Birds: They have feathers, they can fly, they lay eggs, and they build nests. These are four of the properties that first come to mind when characterizing the bird groups. In fact, a bird and its nest belong together so absolutely in our minds that the idea has gone beyond biology and become a motif in the works of poets. The nest types of birds are as varied as the feathered societies themselves: bare rock as a base for the eggs, as with murres; a few rolled pebbles, for some penguins; caves dug into the earth, as with kingfishers; tree caves, as woodpeckers and hornbills make; oven-shaped clay nests, whose feathered creators are therefore called ovenbirds; mud nests, built by flamingos in still waters; saliva nests, the edible nests of cave swiftlets, which are the tropical relatives of Western swifts; and, of course, the classic bird's nest made from branches, feathers, moss, grass, and even webs, like those some hummingbirds build. Some birds will even use scrap metal or plastic trash in their constructions. Birds' nests are primarily well camouflaged and thus hidden from enemy eyes. However, some are visible from far away, appearing as impressive fortresses.

Precocial birds, which leave the roost directly after hatching, are laid in nests that are easier to build than the nurseries of nidicolous birds, or birds helpless upon hatching. Vulnerable nidicolous hatchlings remain in the nest for a longer developmental period, so it should protect them from tumbling out or cooling down too quickly. Closed cup nests handle both of these problems well.

The nests that ensure the survival of their occupants are the result of natural selection. The fact that specific forms of nest construction also play a great role in sexual selection may seem surprising, but it is true—as will be shown.

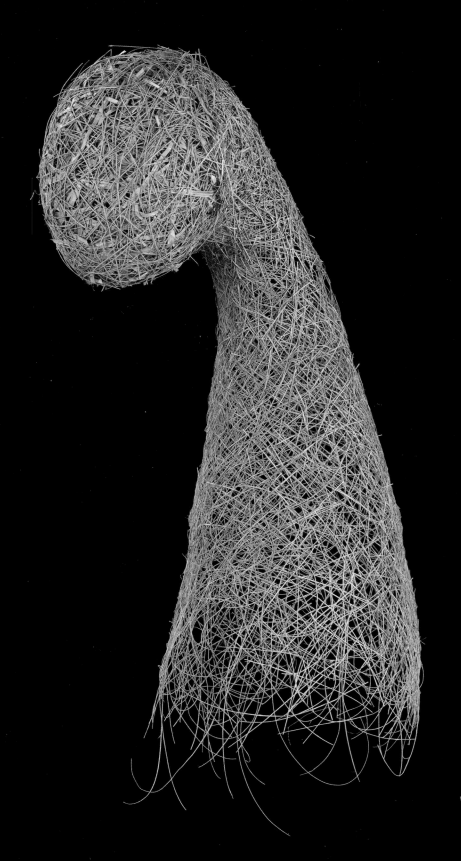

WEAVER - NEST
GRASS

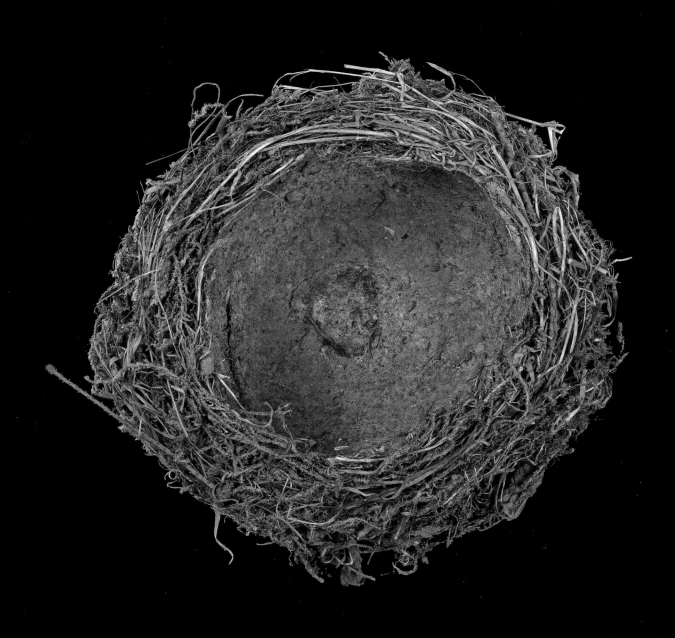

SONG THRUSH - NEST

MOSS, GRASS, ROOTS, BRANCHES, CLAY

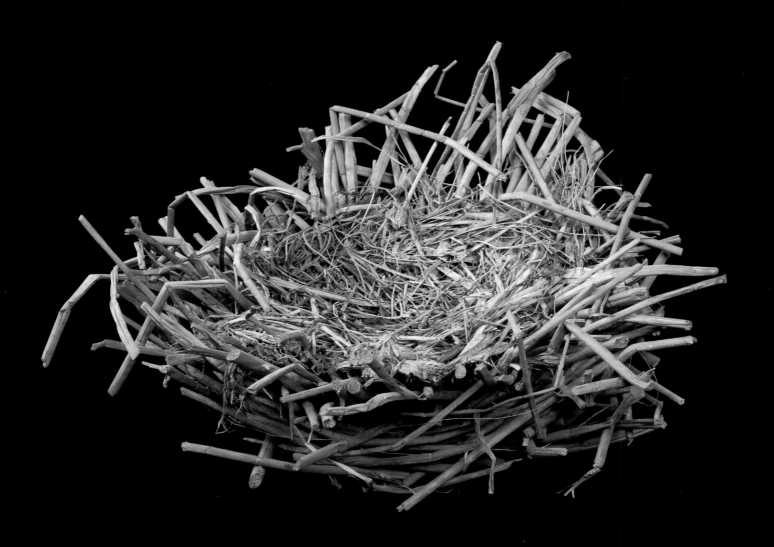

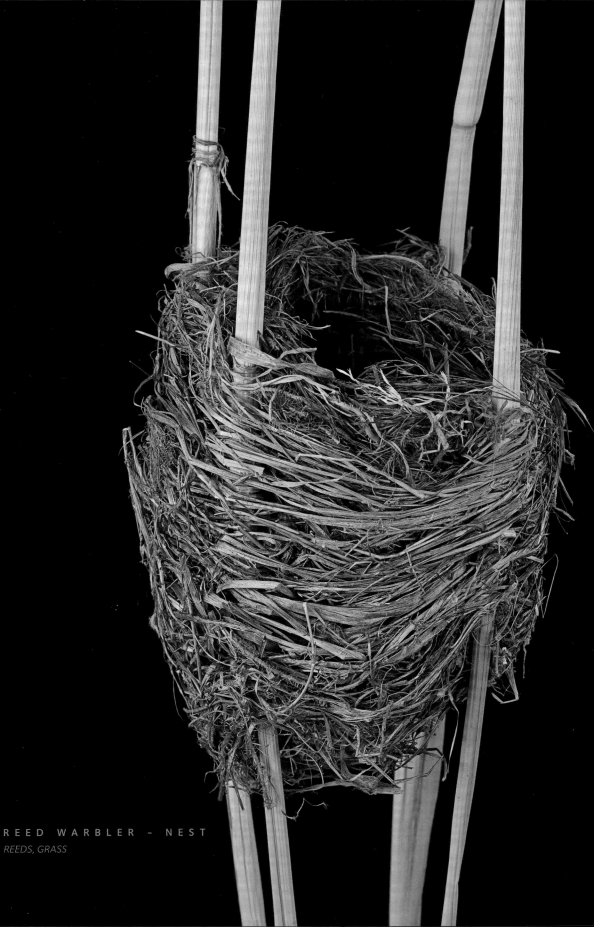

REED WARBLER – NEST
REEDS, GRASS

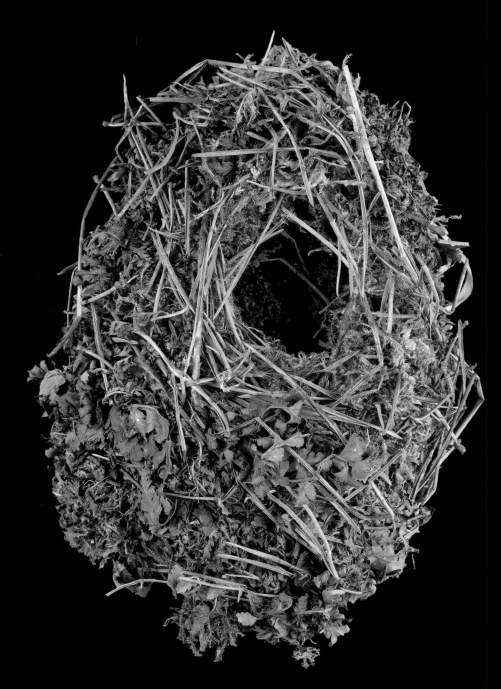

WREN – NEST

LEAVES, MOSS, GRASS, FERNS, SMALL BRANCHES

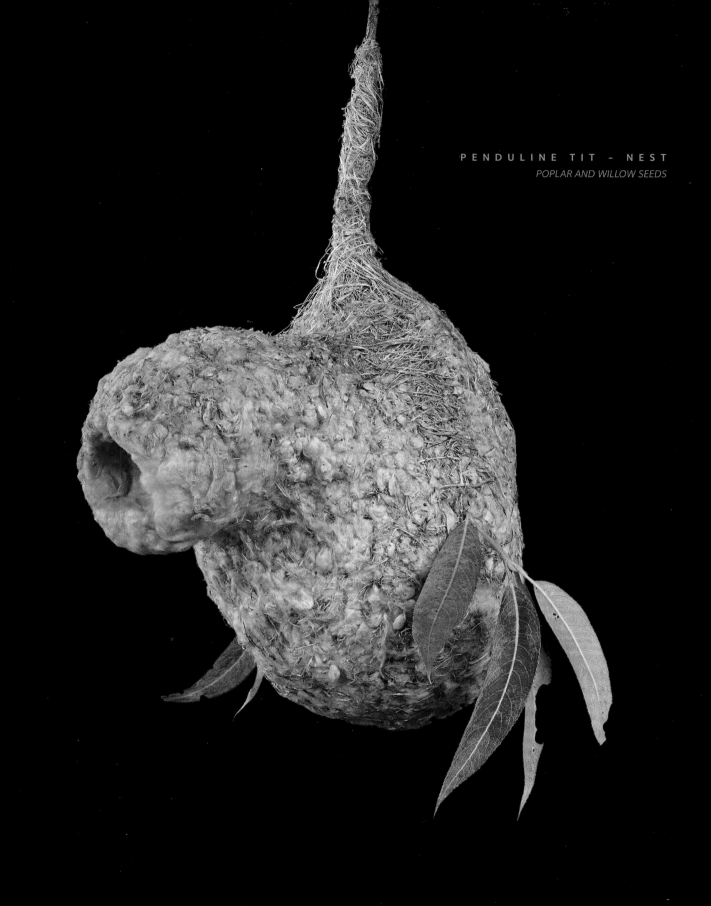

PENDULINE TIT - NEST
POPLAR AND WILLOW SEEDS

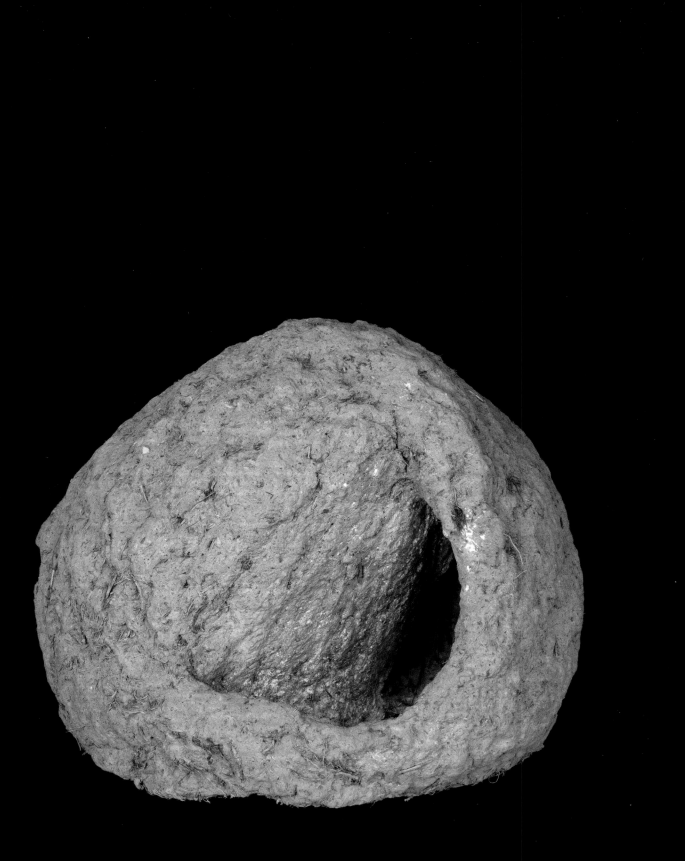

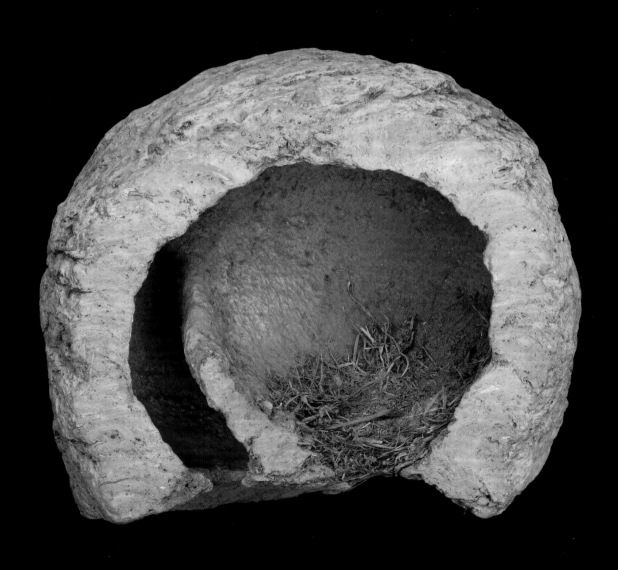

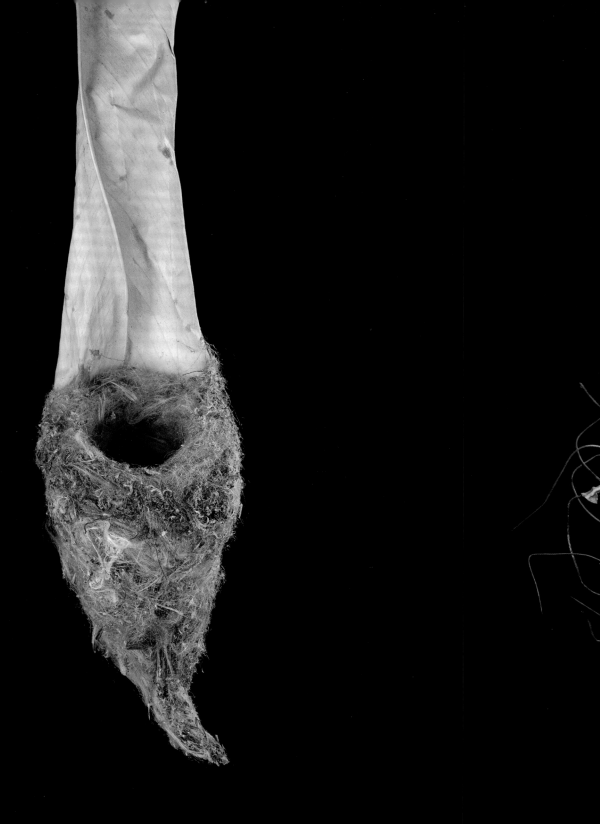

HUMMINGBIRD - NEST
PLANT FIBERS, MOSS, ANIMAL HAIR

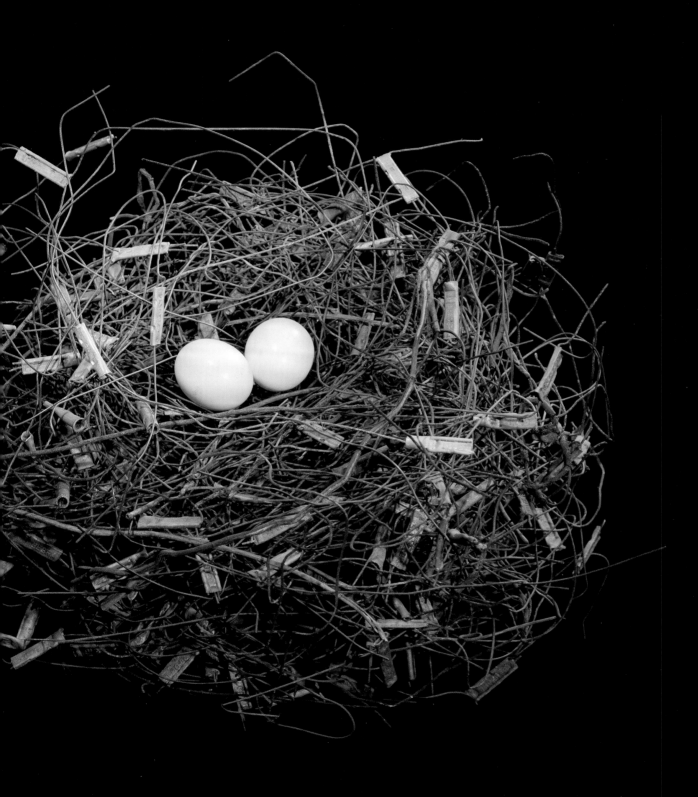

BIRDS *The Purpose Determines the Structure*

The enormous variety of birds' nests is primarily based on the size differences among bird types and on the building materials used. However, there are nest constructions that are so far out of the ordinary that they deserve a closer look.

With the bowerbirds of Australia and New Guinea, of which eight different species have been identified, the males and females each build their own nests, which are completely different. The females build simple bowl-shaped nests for themselves and their babies in the branches of bushes or trees. There, they hatch their young and feed them until they are independent, without the support of the male. In contrast, the nests of the males can be viewed as pieces of art. These constructions have a completely different function from the females' nests: They do not serve for breeding or as a nursery; they are purely love nests. Their sole purpose is to convince the females of the species that the builder of the nest is the perfect mating partner and, thus, the ideal father to their future offspring. The males put forth enormous effort with this as their goal: First, they clean the forest ground, smoothing the surface

where the seduction palace will be built. Then they stick parallel rows of small branches in the ground, forming a tunnel-shaped bower. They will spruce up the forecourt, the ground inside the bower, and often the inside walls with colored objects. A particular color usually dominates, but when several are used, the males arrange the objects cleanly, keeping the colors separate. Alongside objects from nature, such as feathers, berries, and blossoms, remnants of civilization—such as bottle caps, glass shards, and plastic bottles—are increasingly found in use. If these objects are not deemed sufficient, some bowerbirds will coat the walls of their bower with colored juice squeezed from berries. Against such a backdrop, a male then performs songs that are accompanied and emphasized by complex courtship dances. What female bowerbird could resist? However, this is exactly the sticking point—if all of this were irresistible, the females would have no choice and would have to submit. But this is not the case. They will turn away if the smallest detail in the entire labor of love displeases them. This is a sexual selection that ultimately leads to ever more extreme excesses through courtship by the males.

On the other hand, if a male is successful, then he has properly performed and executed the ritual. Because the male bird doesn't need to look after the begotten offspring, after mating he immediately tries to use his investment in the love nest to his advantage: He begins to court another female there.

Male weaverbirds build similarly extravagant and clever nests. Here, too, the female decides, after inspection of the finished nest, whether it appears good enough for her future children; if so, she accepts the male as the father. The structure is then used as a brood nest and nursery. However, if a nest displeases a female, it is not uncommon for the male to tear it apart and build a new one. Because the male isn't sure until the end whether his architectural achievement will convince the target to mate with him, he does not initially tighten the knots and loops completely, so that a dismantling can occur quickly. Because of this, the name "weaverbird" could not be more suitable for this sparrow relative. Twisting and tying with their feet, and particularly their beaks, the birds weave and knot as if they have completed an expert basket-weaving course. Extremely durable nests are constructed in this manner. Moreover, it is easily possible to connect several nests into a communal nest with this technique. Such communal nests—in which often more than one hundred nest entrances have been counted—form impregnable fortresses against enemies. In fact, the greatest threat to such a bird castle comes from within: If the structure becomes too big and heavy, the tree that bears it will collapse along with the nest itself. However, such a misfortune is rare, and as a rule, the communal nest offers a secure home for many generations of the small, feathered builders. Specific architectural tricks in the construction of the single nests provide for additional protection as well: Long access tubes previously knitted into the nest make it hard for tree snakes, in search of a meal of birds, to plunder such a dwelling.

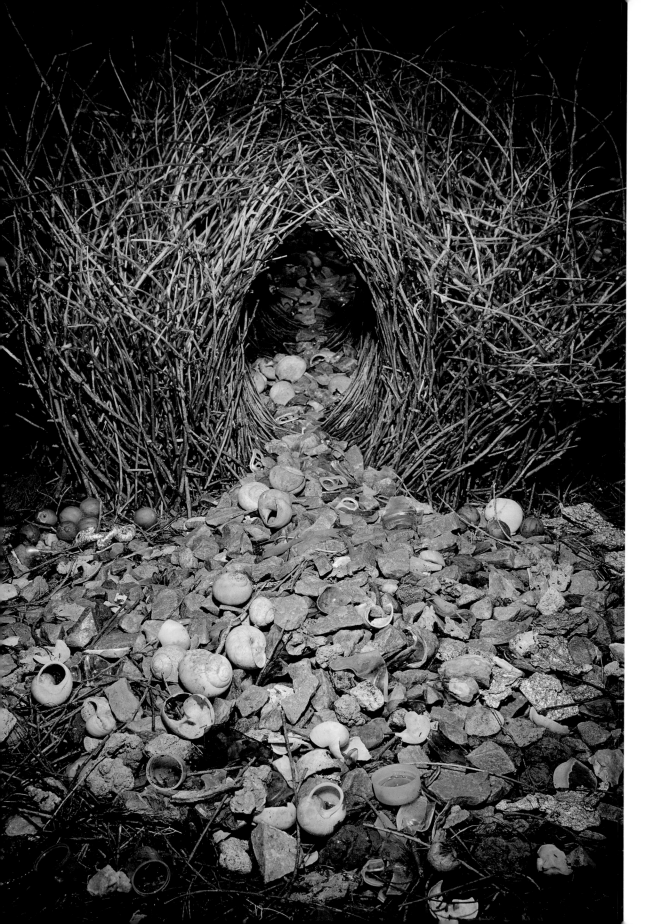

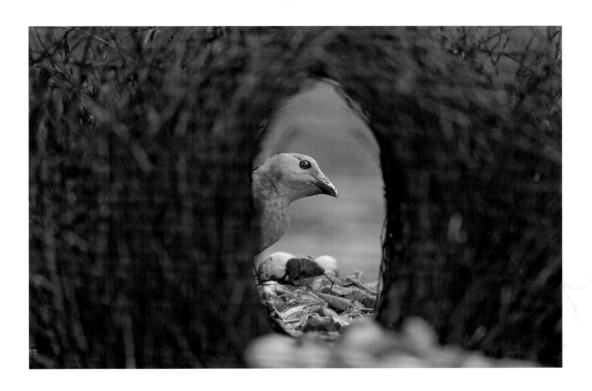

The gray bowerbird of Australia builds a mating arena from artfully interwoven sticks and covers the floor with all manner of decorative objects and pebbles. It wants to impress a female with its construction work and persuade it to mate. After the courtship display, the female bowerbird builds a simpler nest in a tree, and she alone raises the young in it.

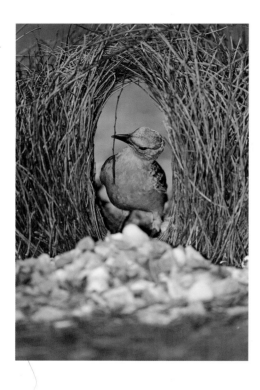

The more beautiful the arbor, the greater the chance a male bowerbird has of attracting females. He happily presents snail shells in prominent places as ornamentation.

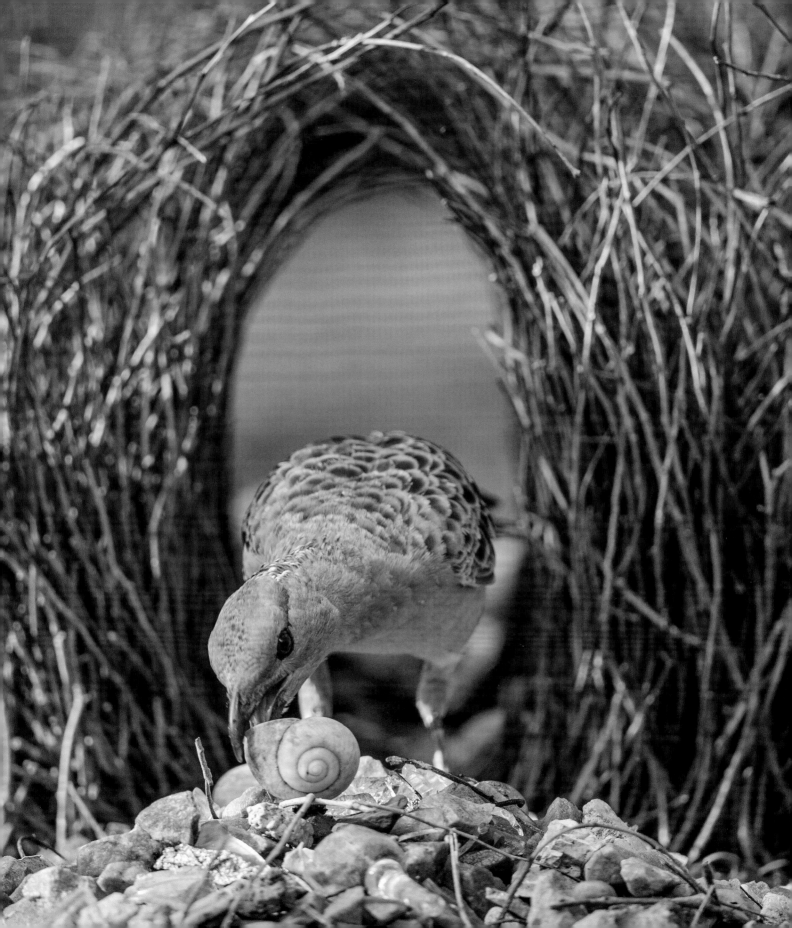

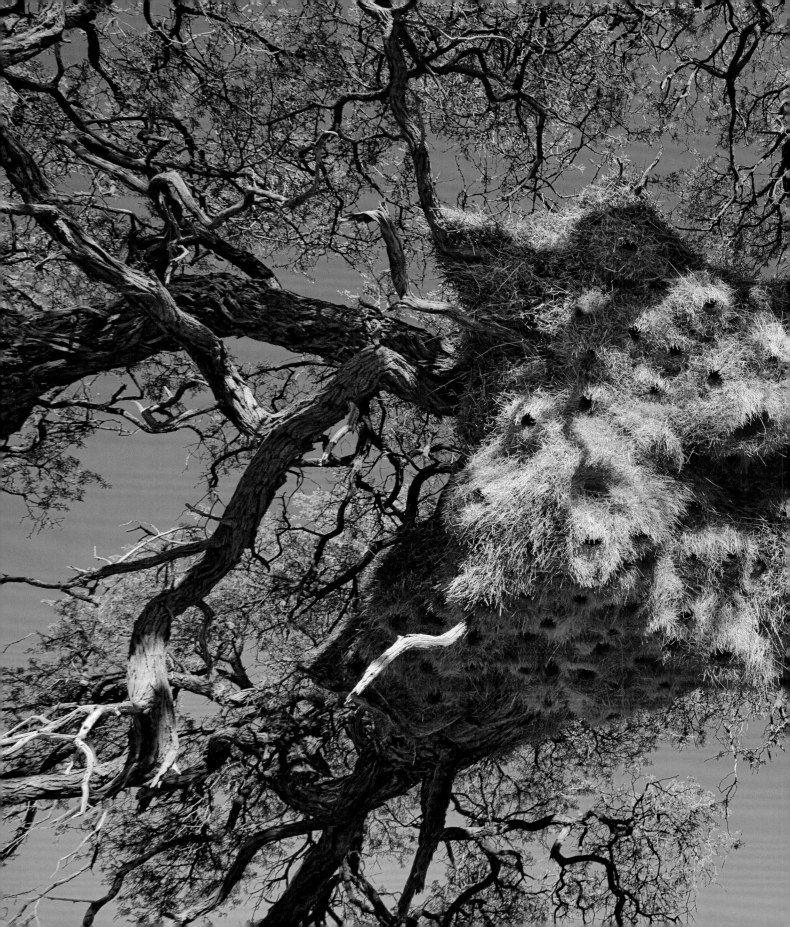

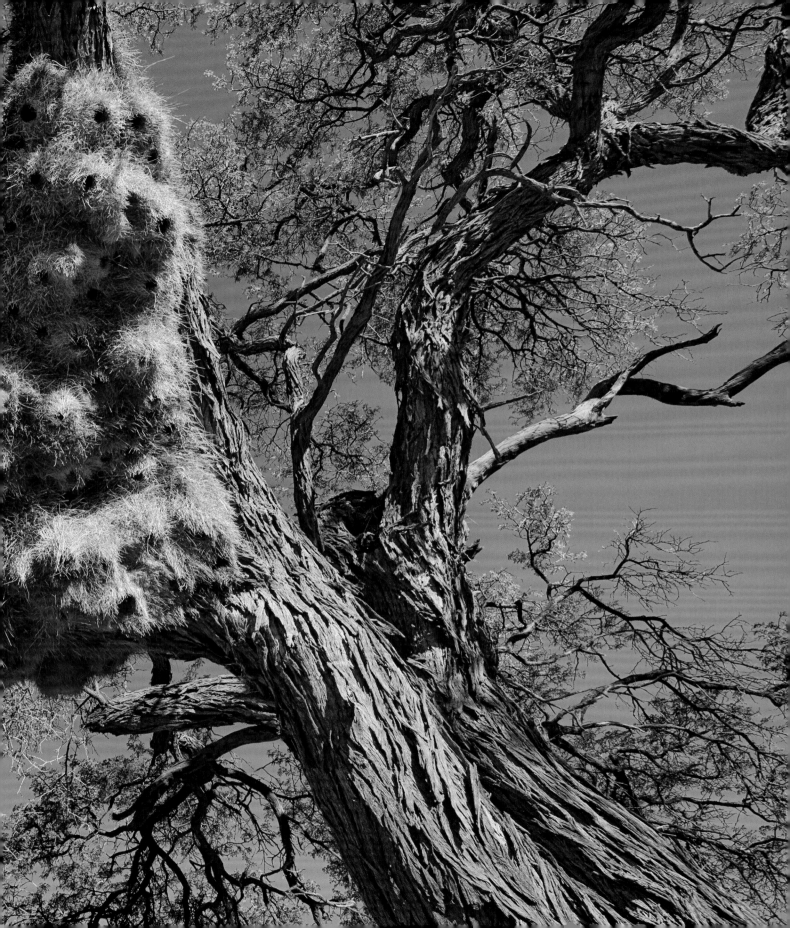

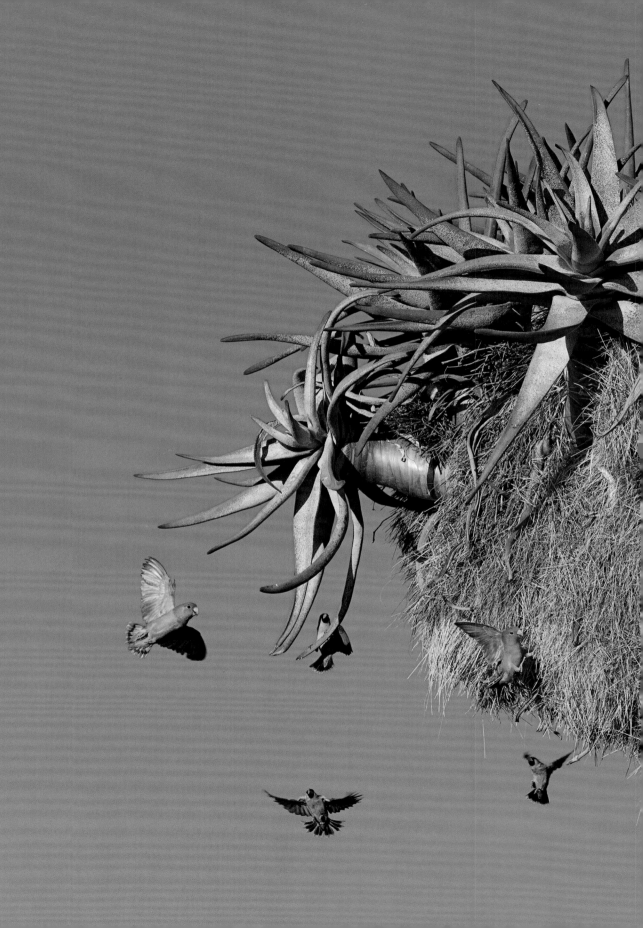

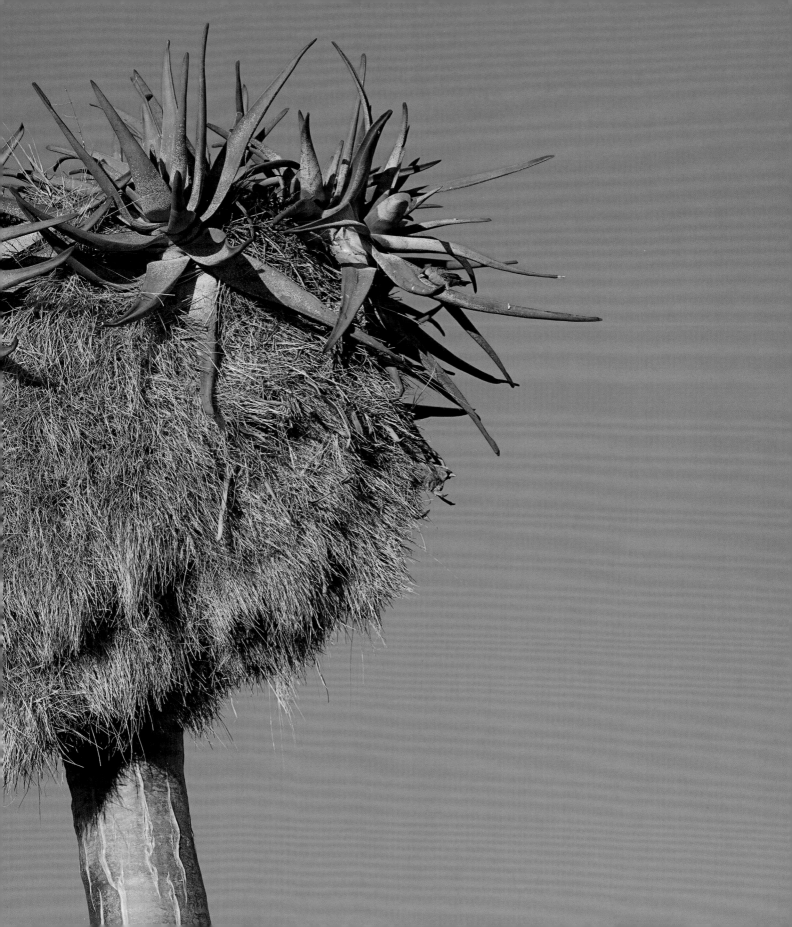

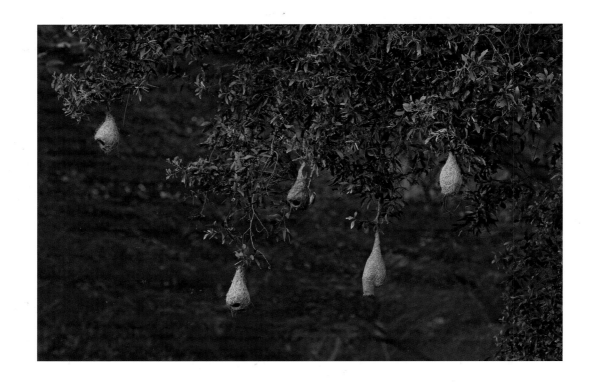

Baya weavers build their skillfully woven nests in small colonies.

(pp. 30–33)
In the seemingly endless plains of Namibia, sociable weavers build their gigantic communal nest. The structure of dry grass accommodates up to a hundred breeding pairs of the sparrow-size birds. Entire trees, which could collapse under the weight of too-heavy nests, are nonetheless usually able to support the structure for many years. Now and then, small parrots will also enter as lodgers.

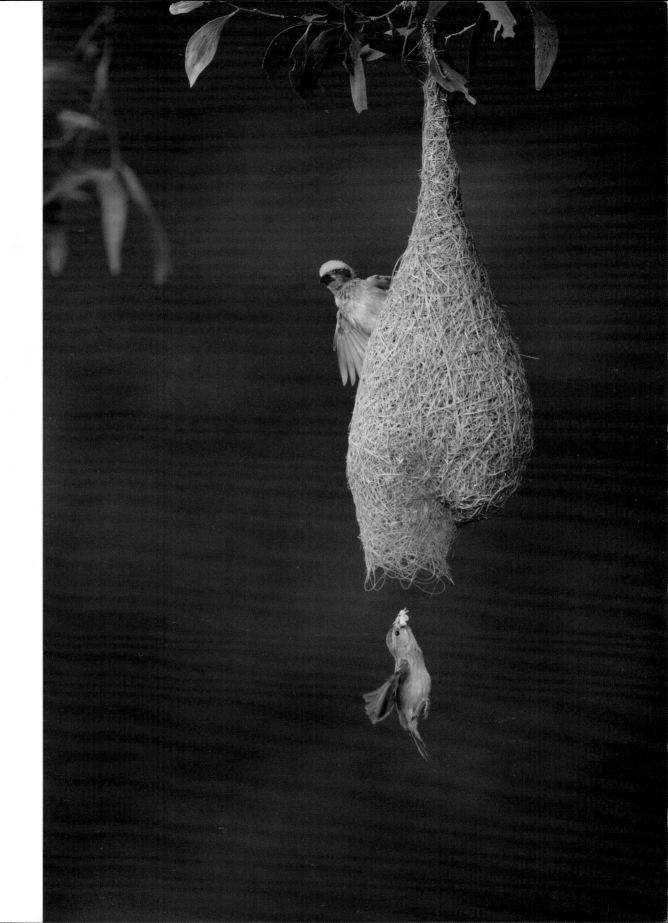

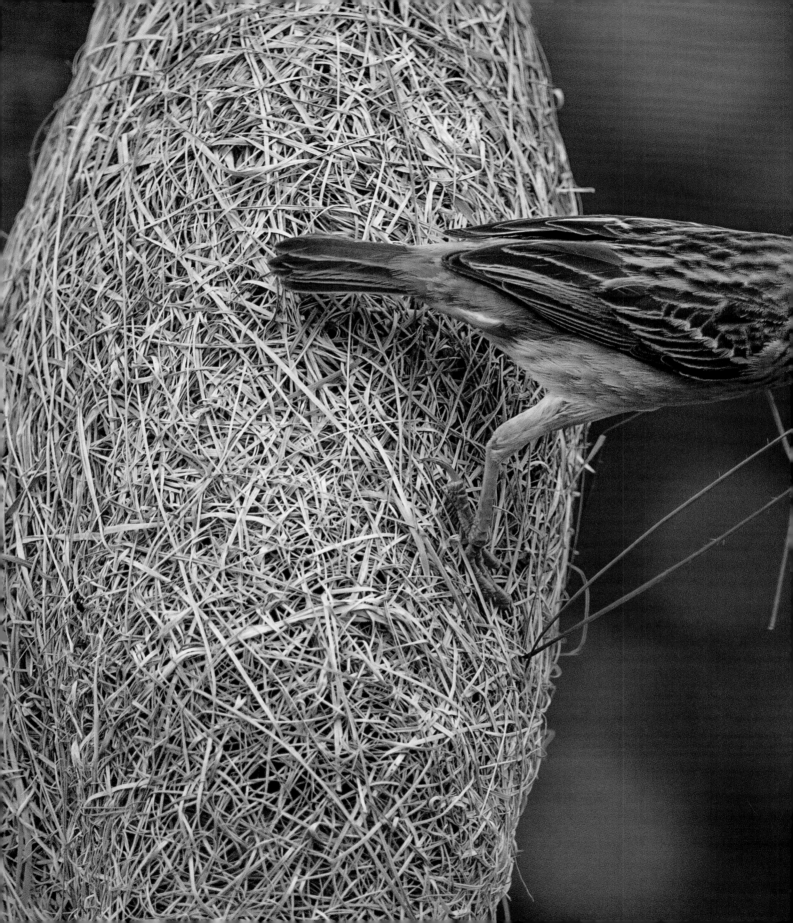

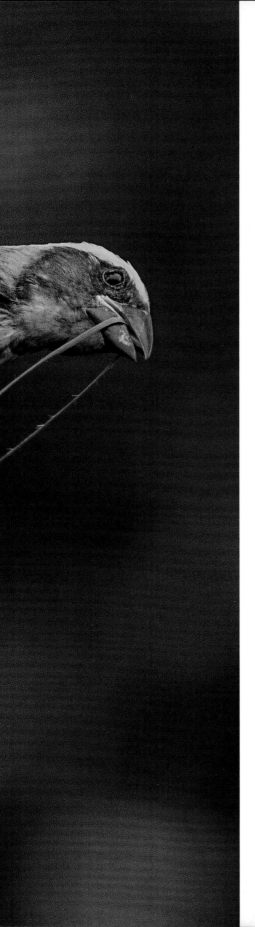

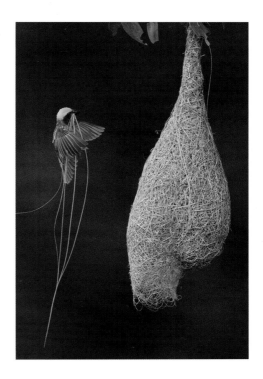

With great skill, baya weavers construct their nests from thin blades of grass. The stalks are bitten off and then used for weaving while still fresh. After a short time, the tropical sun dries the green blades and the nest hardens and changes color.

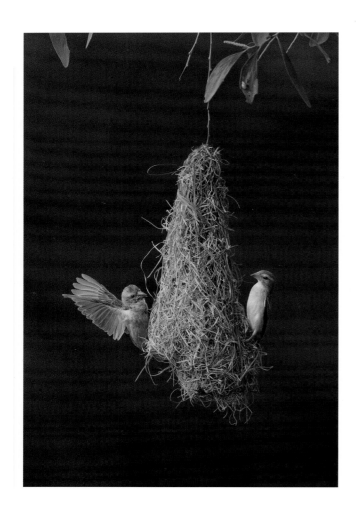
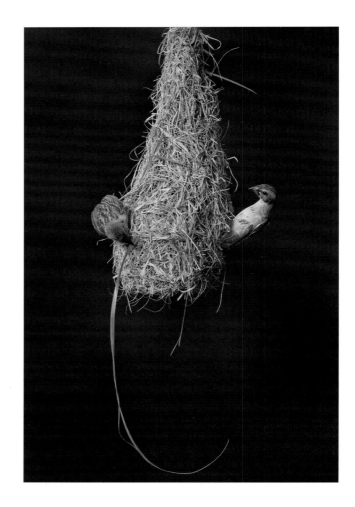

It is a priority for weaverbirds to learn elaborate nest building. Shown here in its imperfect state is a "training nest." Various young birds use this type of nest to practice their skills.

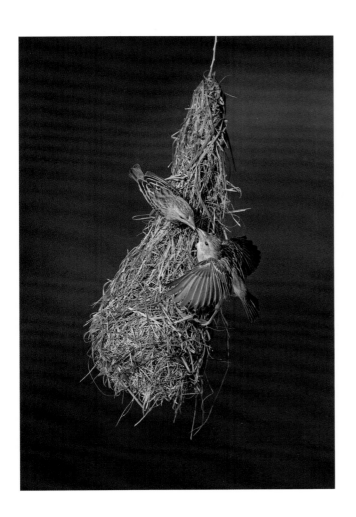
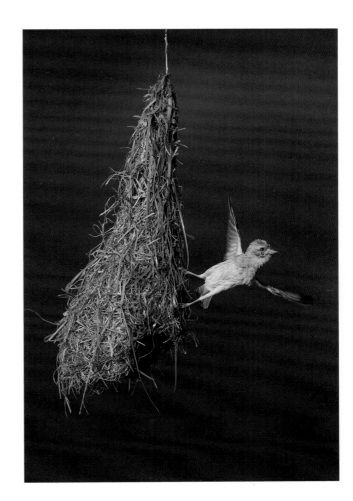

Again and again, there are quarrels in the nest-building training. Occasionally, adult birds will steal blades of grass from the training nest for their own constructions.

Only tear-proof grass varieties with high stability are used by the baya weaver to build a nest. The artistic constructions are waterproof and can even survive severe tropical storms without breaking apart.

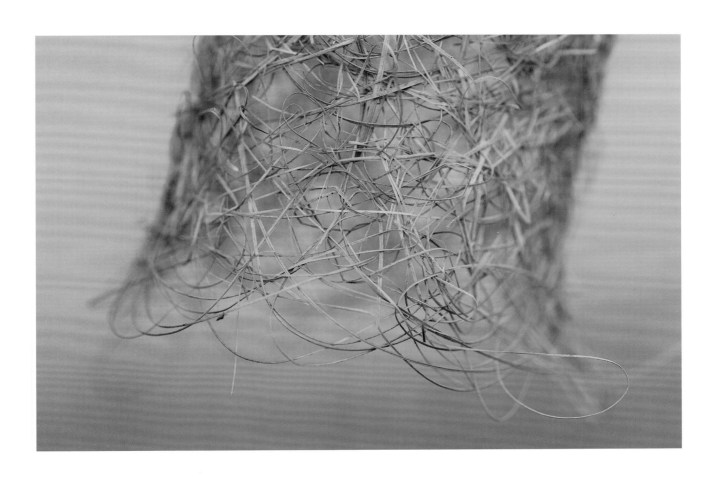

The loosely interwoven entrance of the nest makes
it clear how cleverly the little birds connect the
building materials.

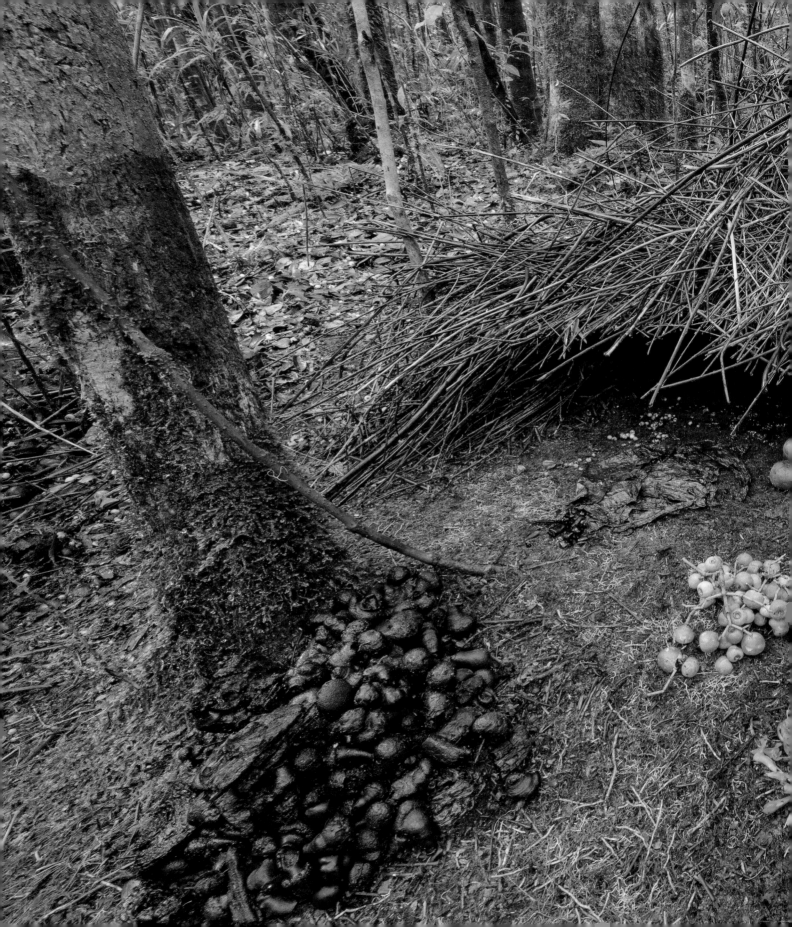

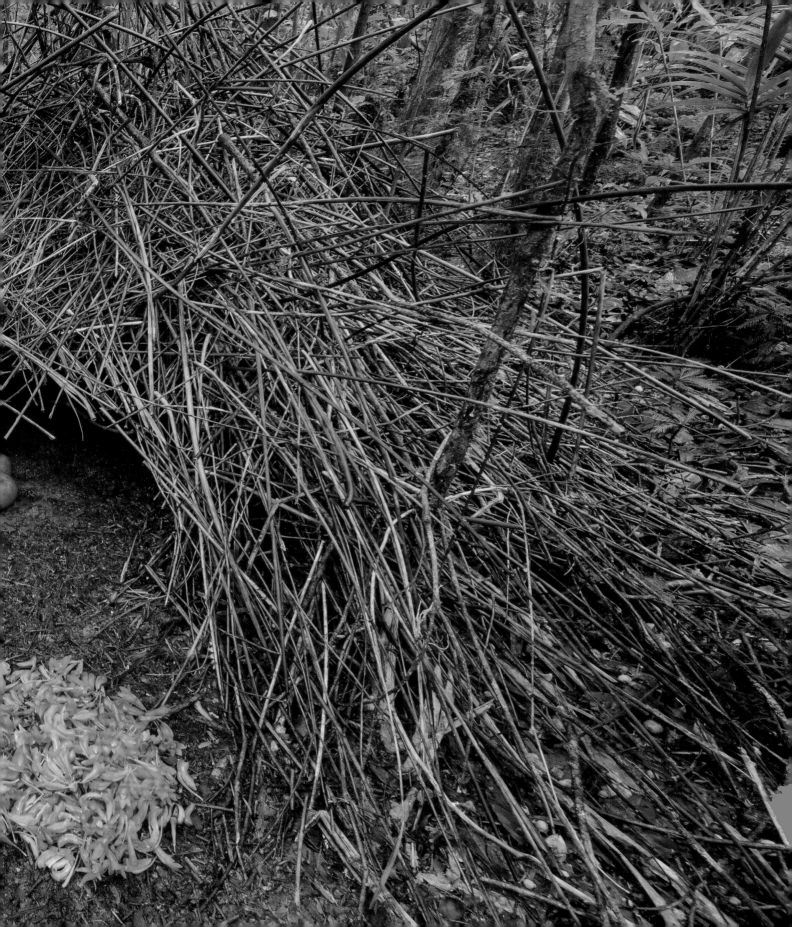

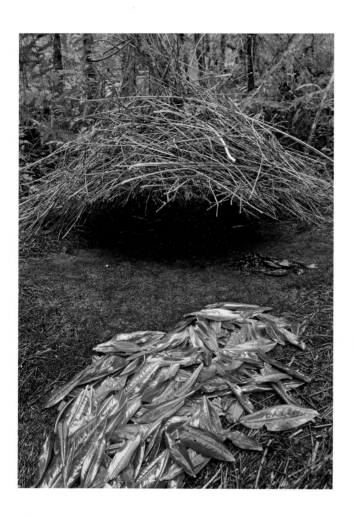
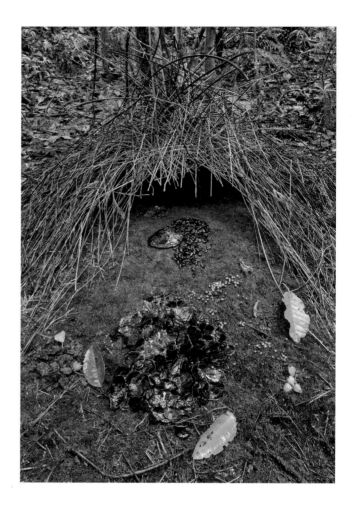

The male vogelkop gardener bowerbird cannot sing
melodiously, dance elegantly, or attract a mate with
looks alone. In order to win a female for himself, he
has developed an entirely different strategy: He con-
structs a splendid bower to impress potential mates.

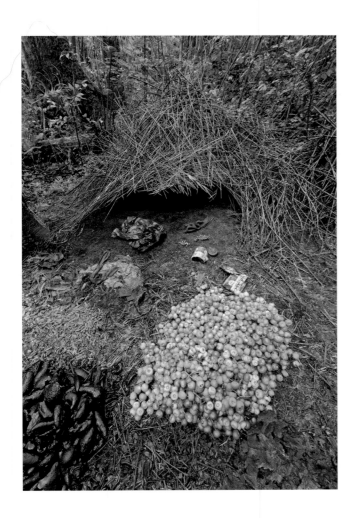

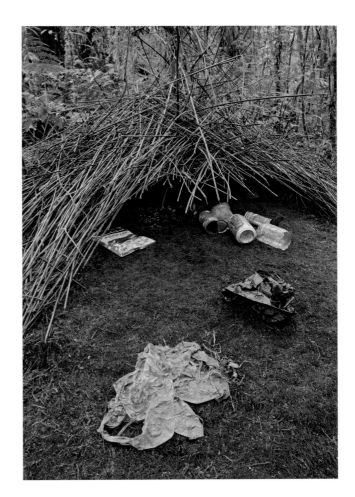

Anything with striking colors is used to decorate the bower: blossoms, fruits, leaves, mushrooms, mosses, and even garbage left behind by humans on expeditions in the Arfak Mountains, the native land of the vogelkop gardener bowerbird.

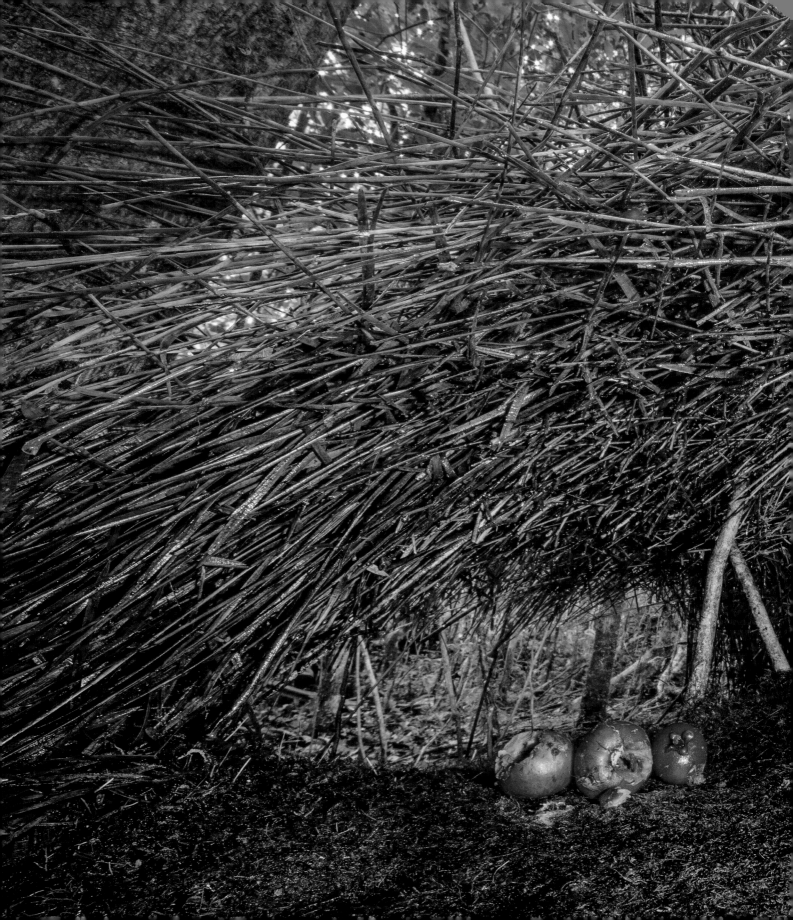

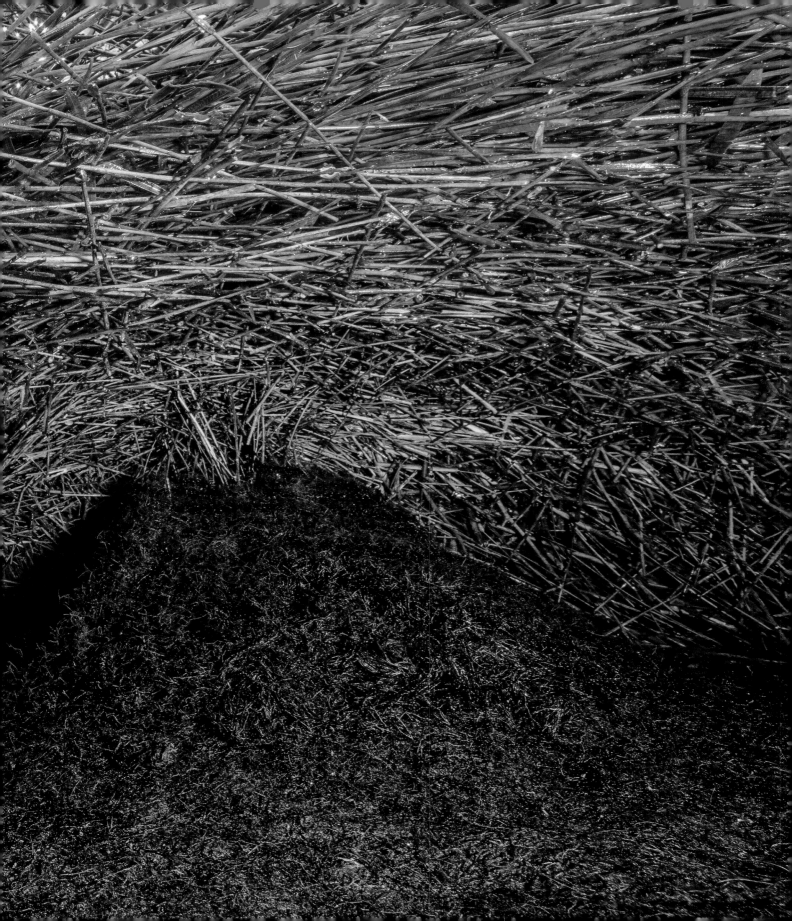

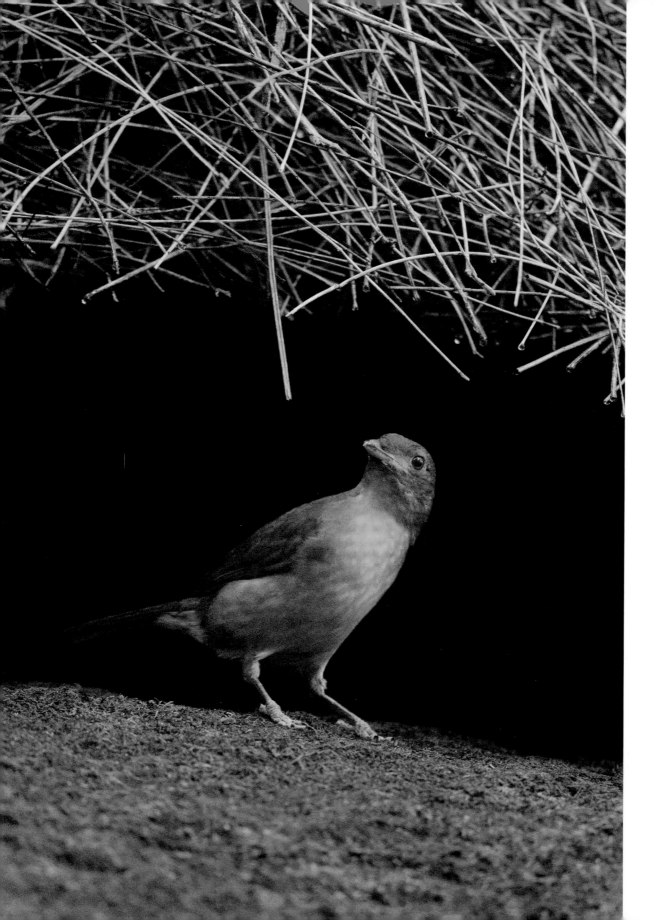

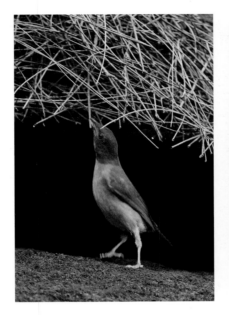
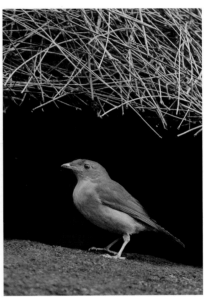

The bower of the vogelkop gardener bowerbird is a complex architectural masterpiece. The tower, called the maypole, is set around a thin trunk. The male pays excruciatingly precise attention to the state of the construction. If a branch slips once, it is immediately moved back into the correct position.

(pp. 50–51)
Many types of decorative materials are used in the ornamentation of the lek (the courtship arena).

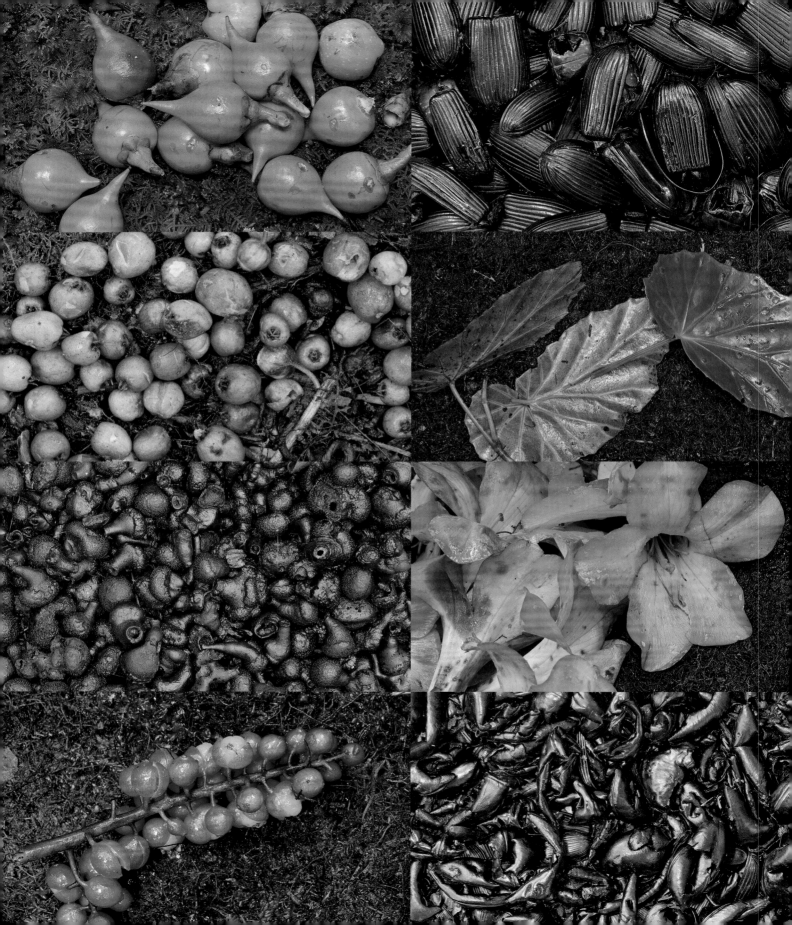

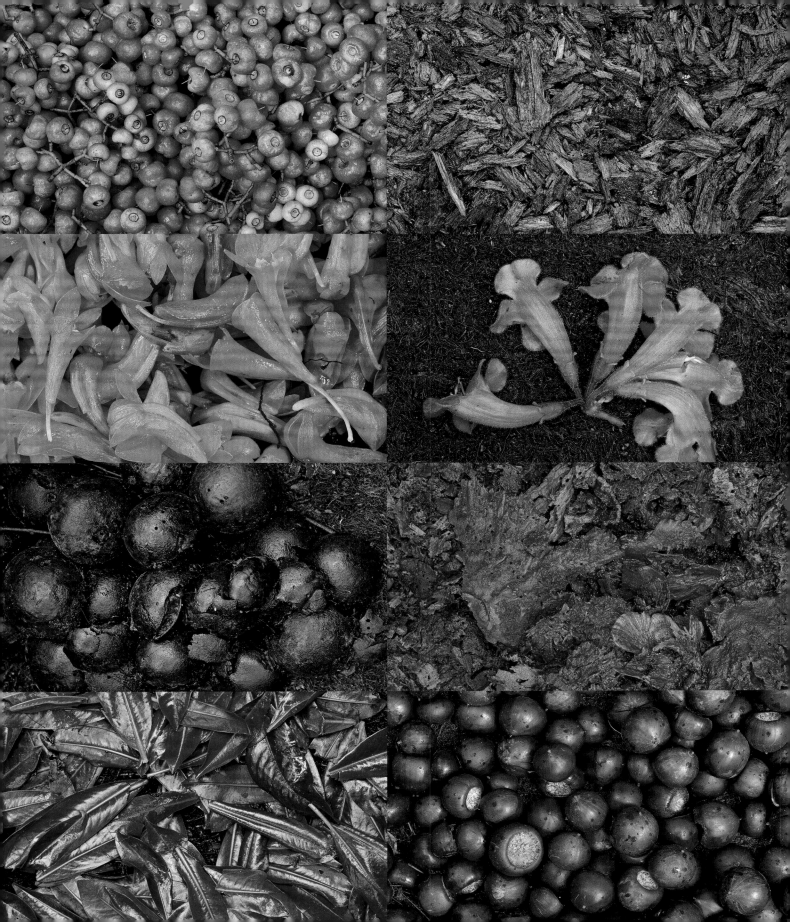

2

CREATORS
OF THEIR
OWN WORLD

THEIR CONSTRUCTIONS ARE INHABITABLE OVER MANY GENERATIONS AND ALWAYS ENVIRONMENTALLY FRIENDLY

A number of researchers see some animal constructions as nothing more than a necessary part of the animal's life, placing the architecture on equal footing with the internal organs of these living creatures. The nests of colony-building insects are an excellent example of this. Like people who would, in a theoretical future, withdraw into a protective dome in order to survive a threatening environment, termites and hymenopterous insects build a world of their own that is largely insulated against the external influences of the environment. These impressive structures of the small six-leggers—zoologically, hexapods—are not only masterpieces regarding the use of materials and the architecture; they should also be considered purposefully genius in how the conditions inside them are controlled. However, we will begin with the more modest, if no less impressive, routine of the caddis flies.

Their larvae live in the water and build protective receptacles—out of pebbles, small shells, or pieces of plant—that they carry around and into which they can retreat in case of danger. Caddis fly larvae are so picky when constructing these homes that experts determine the method by which they selected their materials on the basis of the casing alone. The case's components are held together with silk threads that the larvae expel from spinnerets in their heads. The cases can also be spun together in a large-scale collaboration. Similar community-built shelters are preferred by certain butterfly larvae. The threads from their spinnerets join the caterpillars in large, widely recognizable nests in which they are safe from birds and can feed on the foliage found in the nest pad in peace and quiet. Spiders' webs, meanwhile, are structures made of silk threads that are not meant to protect their producers and owners, but are instead sophisticated traps that capture many victims. Filigree, barely detectable and often equipped with adhesive droplets, brings flying insects to their downfall. For this we should be grateful—without these fine, entrapping webs, humans would be harassed by flies and other insects in greater quantities.

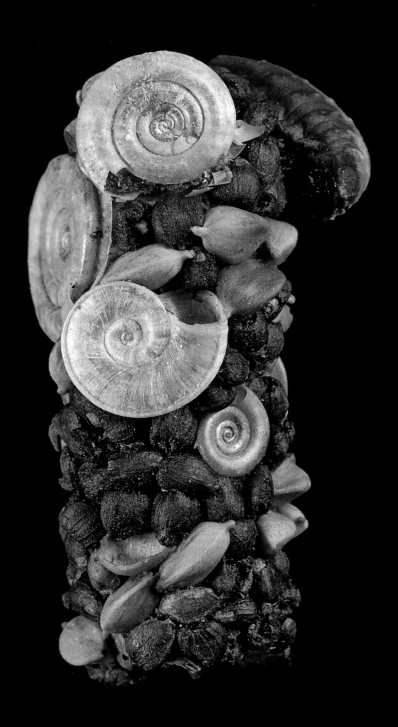

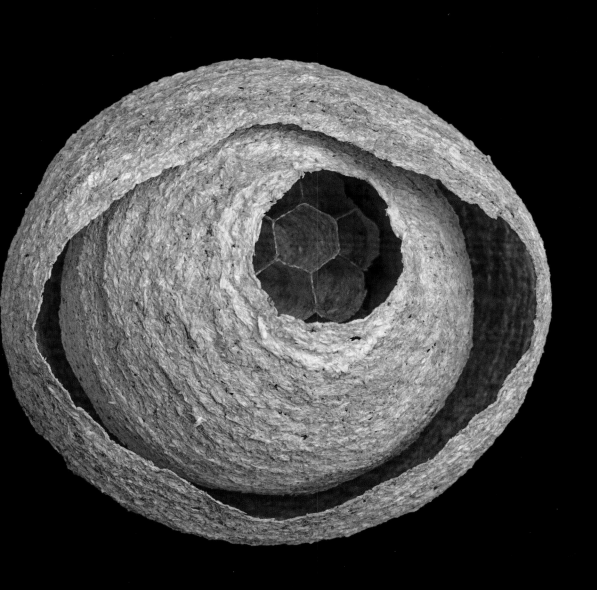

WEAVER ANTS - NEST
LEAVES, SILK THREADS

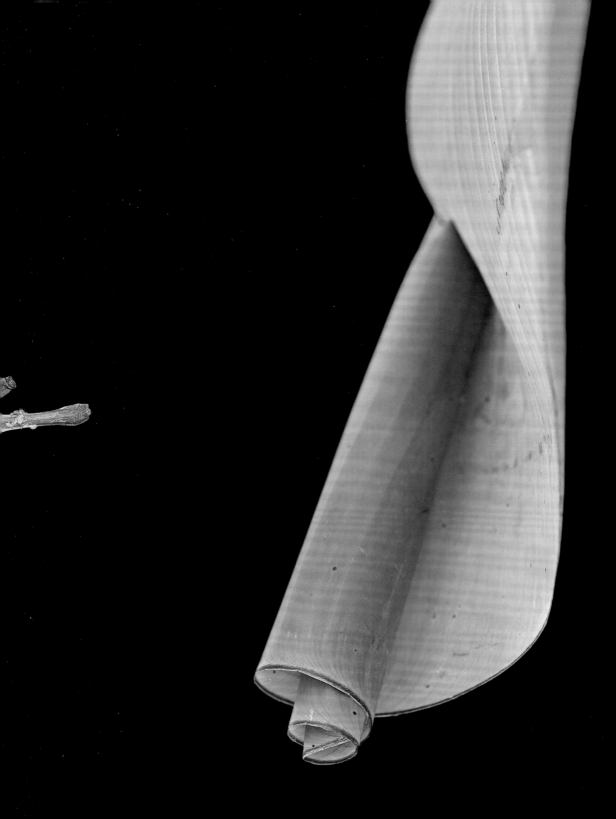

ARTICULATES *Creators of their own world*

Ants, wasps, honeybees, and termites are the un-crowned champions of the architects of the animal kingdom. This isn't just because of the sheer size of the constructions that these social insects establish; it's also the admirable manner in which they build them and how ingeniously the completed construc-tions are utilized.

Colonizing insects carry out a division of labor. They assign special duties to infertile members of their colonies and produce cooperative communal achievements that the individual creatures would not be able to achieve alone. This mentality applies not only to their amazing structures, but also to the regulation and organization of the internal world of their nests.

One of the building materials of wasps is a type of paper, a material created from wooden particles and the wasp's secretions. From this paper, the tiny build-ers form roughly hexagonal cells, which can then be placed in horizontal hanging combs. Typically, large wasps' nests consist of several of these combs, neatly aligned in parallel lines and connected to one another by centrally mounted pedicels that keep them separated. Several layers of the wasp paper close off the entire ensemble from the outside, and there is only one small entrance. Not only do these layers offer physical protection, but also the air between the combs protects against strong external temperature fluctuations. Under a brick roof—a location that wasps often use as their construction site—the temperature can easily rise to higher than 122°F (50°C) in the summer. Without the insulating air layers, these high temperatures would be deadly for the wasps and their brood.

The nests of weaver ants dangle high above in the branches of tropical trees. The leggy insects pull together leaves and interweave them at the edges with silk threads. In order to do this, the adult builders need the help of their larvae, because only they can spin the threads. The larvae thus become tiny weaving shuttles that move back and forth until the construction is completed. The load-bearing capacity of the branches sets the limit for the size of these constructions.

Most types of ants behave in different ways as they build their nests. The constructions of the leaf-cutter ants, recognizable above ground as a hill, often run many feet deep into the ground. Lying within the chambers are certain mushrooms that the tiny gardeners grow for food. The thick air that originates within is exchanged through an ingeniously applied funnel and duct system that uses the wind as an engine.

Indeed, the surface portion of the ants' nests is also impressive, and not only in the tropics. Red wood ants build enormous hills from countless amassed needles from surrounding trees. Inside such a hill, and in the part of the nest that often runs much deeper into the ground than the hill is high, industrious activity rules. To create an ideal climate for the hill nest, small openings are made on its surface that are kept open or closed according to need. If it gets cold in the nest, the entrances are blocked, but not before some of the ants that have been warming in the sun have marched into the nest to act as passive heaters for a long period of time until their temperatures drops again. In winter, everything is completely closed up on top and the ants withdraw into the earth at depths that no frost can reach. The nest hills are laid out within the landscape so that the warming spring sun can quickly bring the zealous colony back into motion again. These ant castles can exist and grow for many years. The small insect cities flourish as long as their queens are alive.

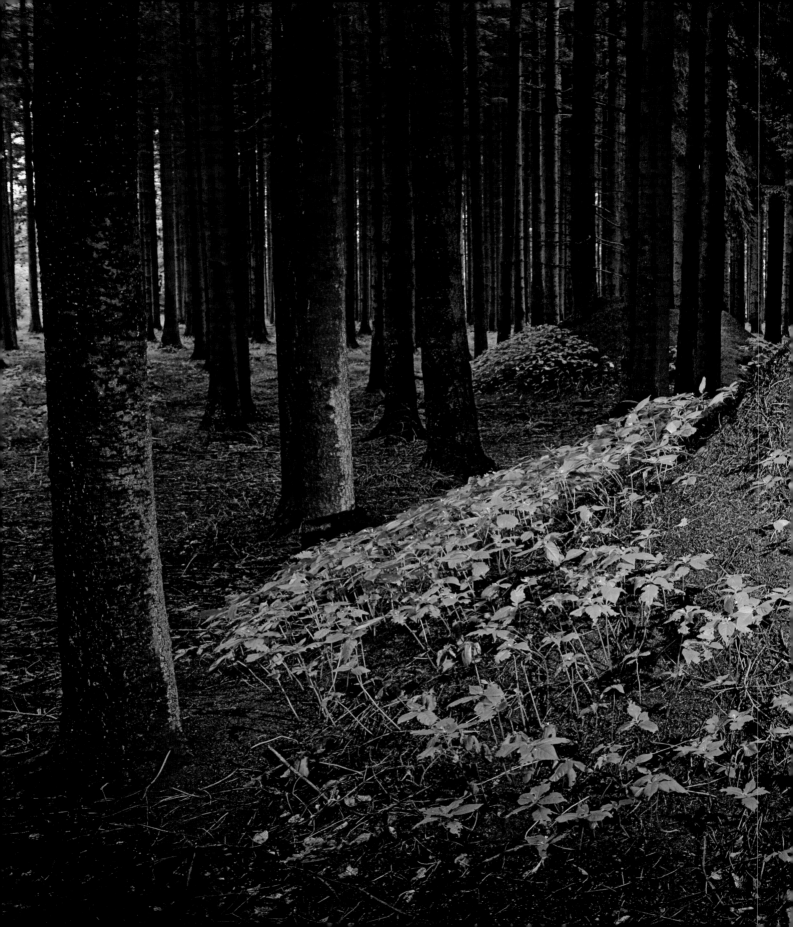

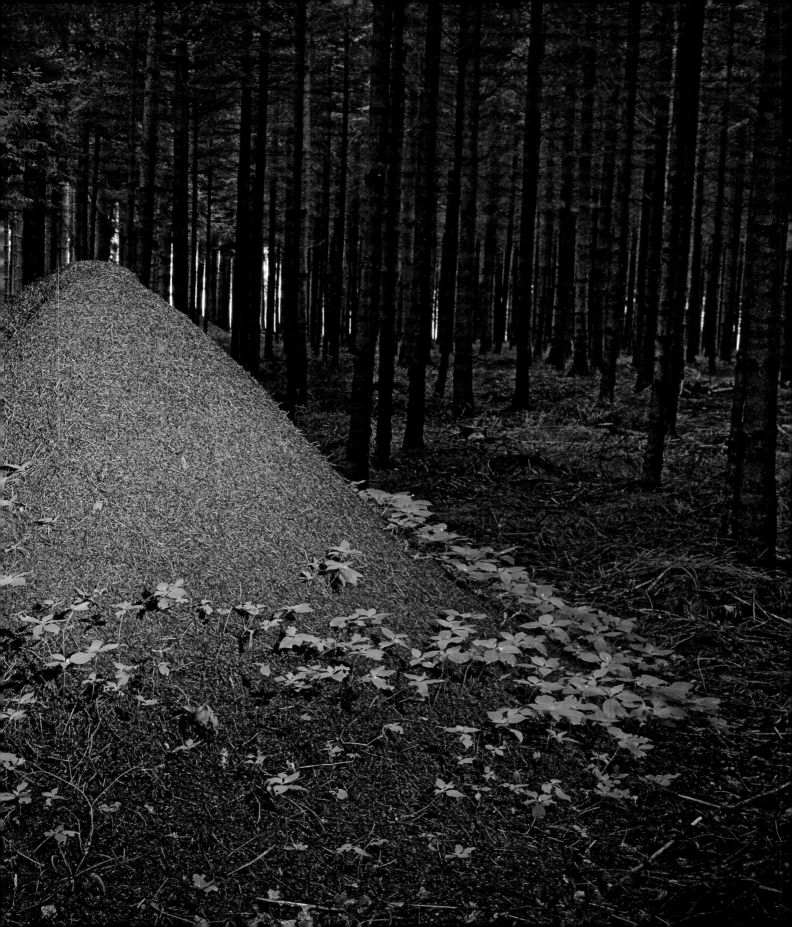

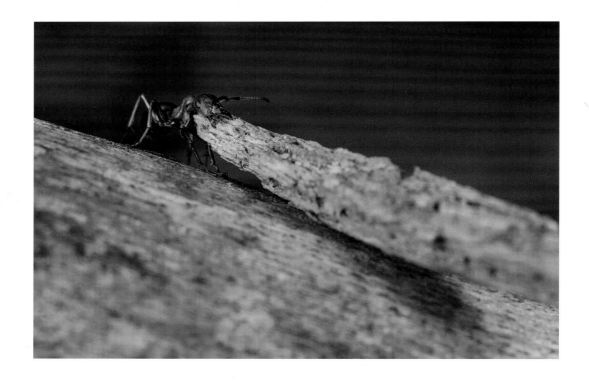

(pp. 60 – 63)

In comparison to their body size of just one centime-
ter, red wood ants build true skyscrapers. Structures
consisting of plant material and earth can reach a
height of more than six and a half feet (two meters)
with a diameter of more than sixteen feet (five
meters). There is a widely branched system of paths
and chambers within this ant tower laid out in such
a way that no water can penetrate. Several hundreds
of thousands of the small insects live together in
one anthill.

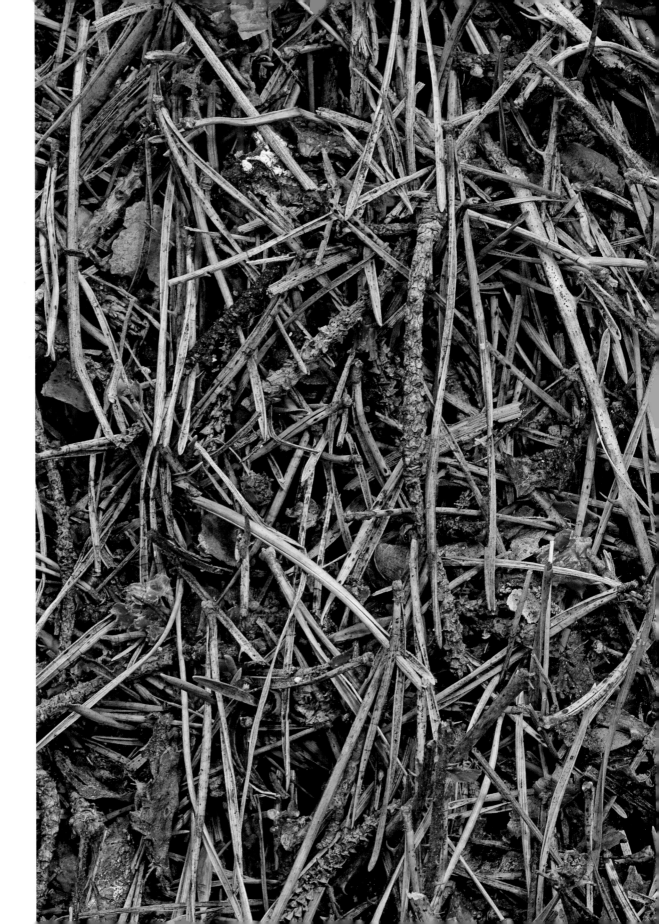

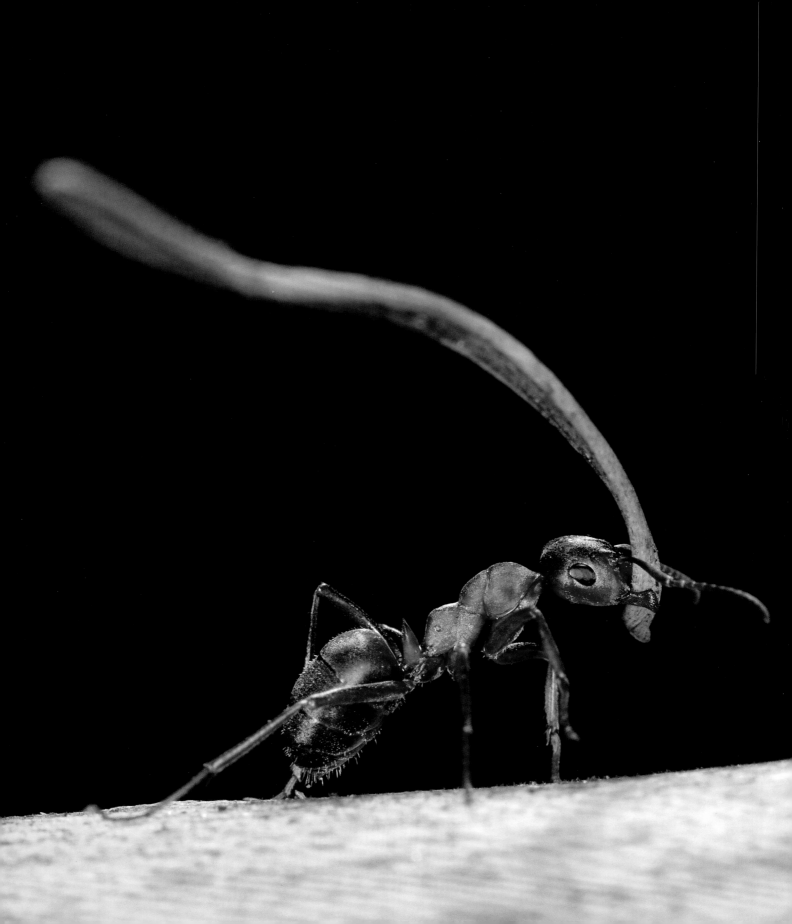

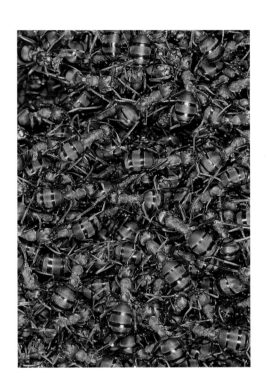

With pure muscular strength, red wood ants transport building materials of spruce needles, small branches, and little pieces of wood; the burden sometimes exceeds their own body weight by forty times.

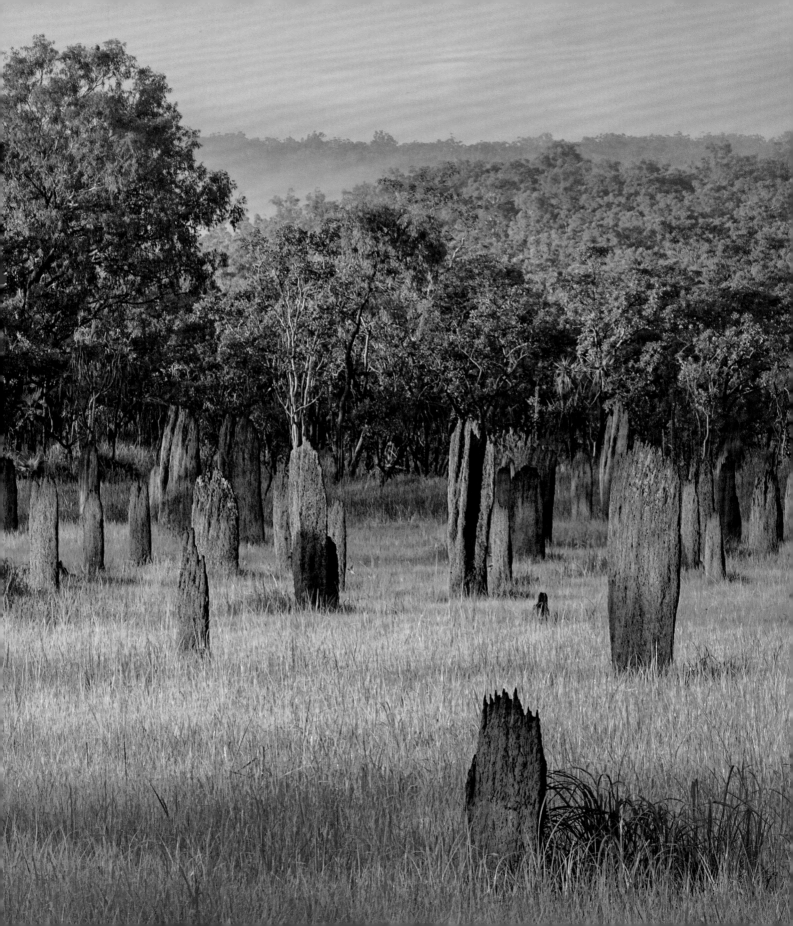

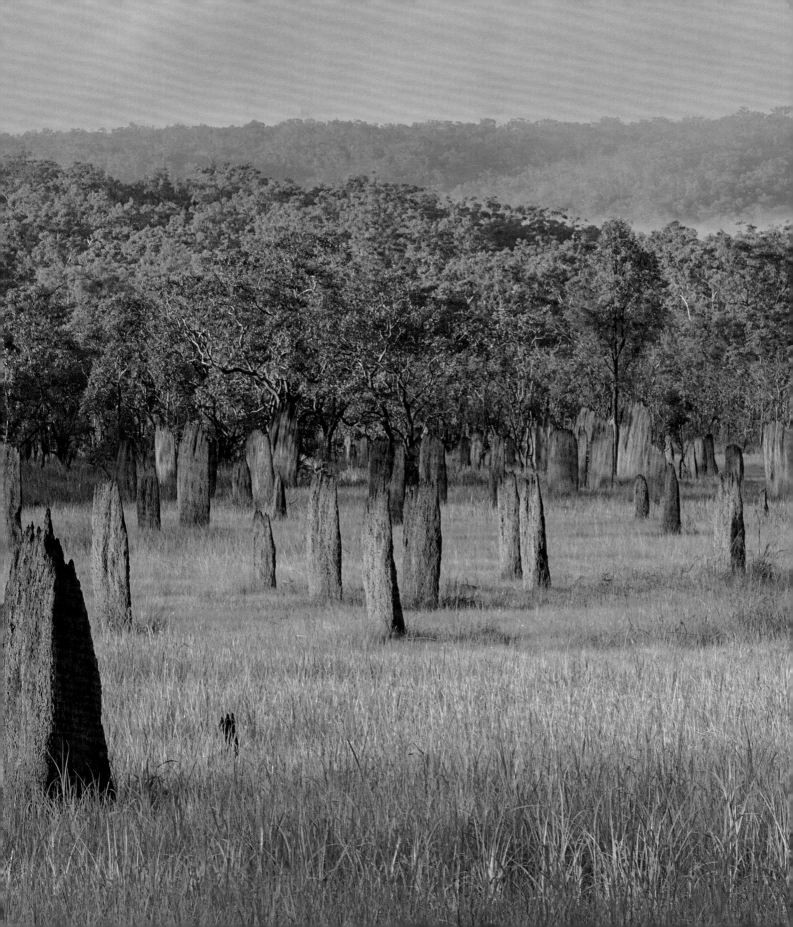

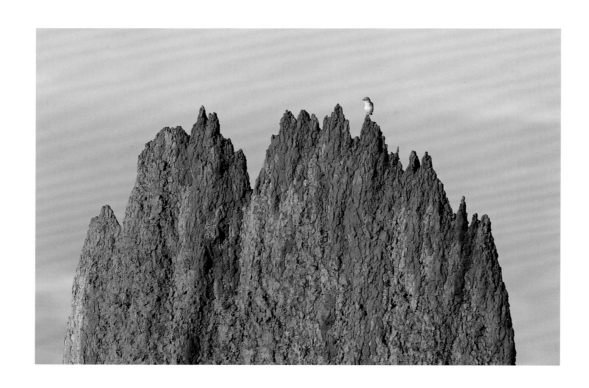

Huge fields littered with the towers of the compass
termite, averaging almost ten feet (three meters) tall,
extend throughout northern Australia. Flat-sided
constructions arranged in a precise north-south
orientation, in combination with an ingenious ventila-
tion system, ensure a constant internal temperature
within the structures. Both the morning and evening
light hit on the flat sides of the dwellings and warm
them up, while during the hot midday, the sun hits
only the narrow, upper edges and thus does not force
the internal temperature to rise.

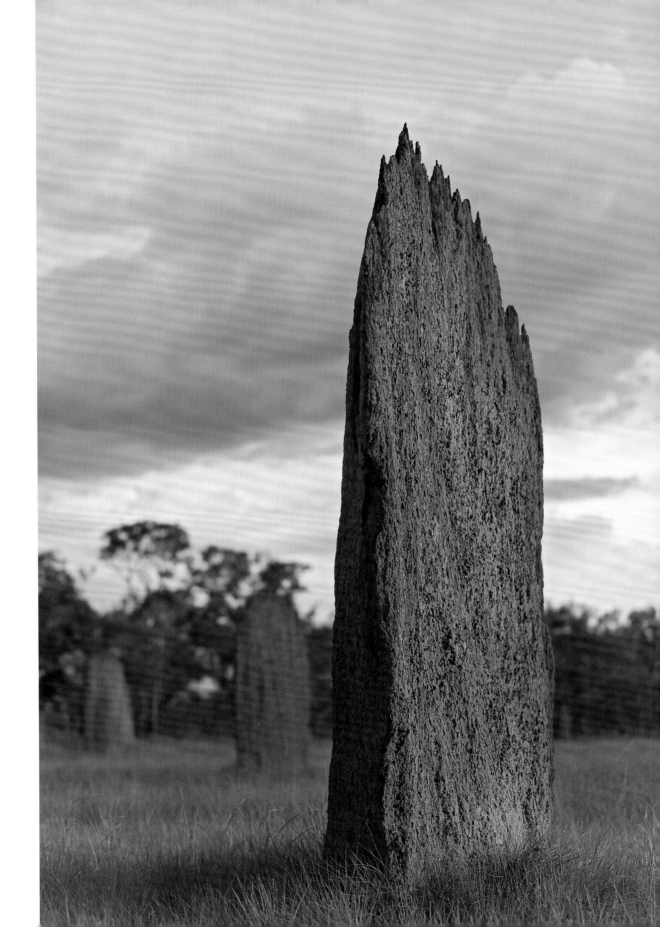

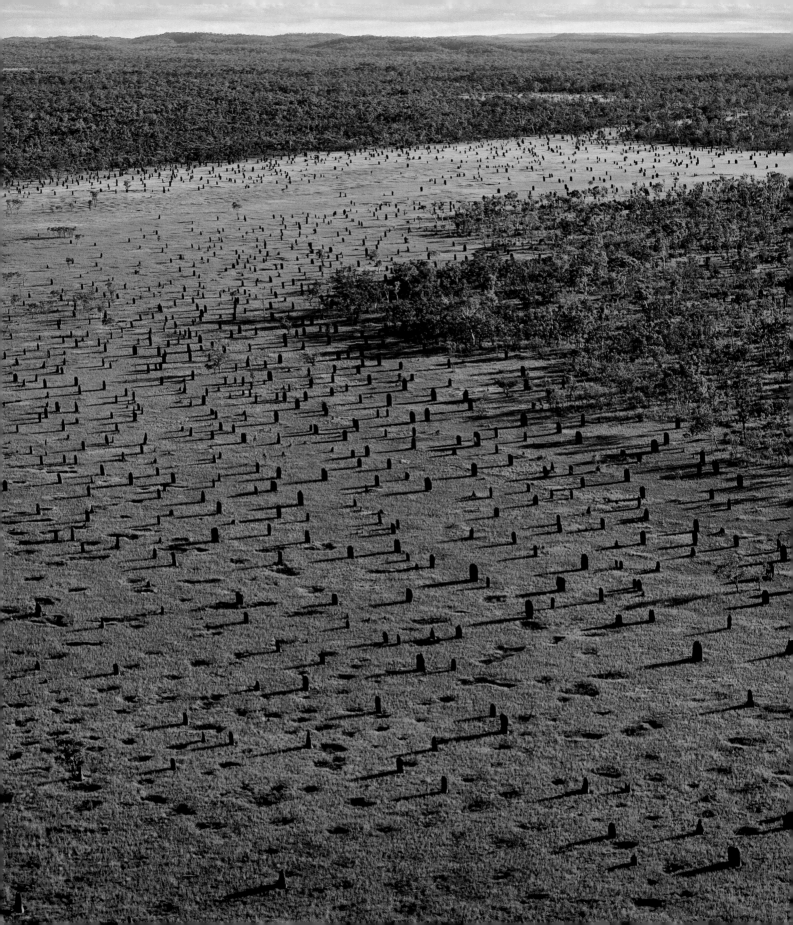

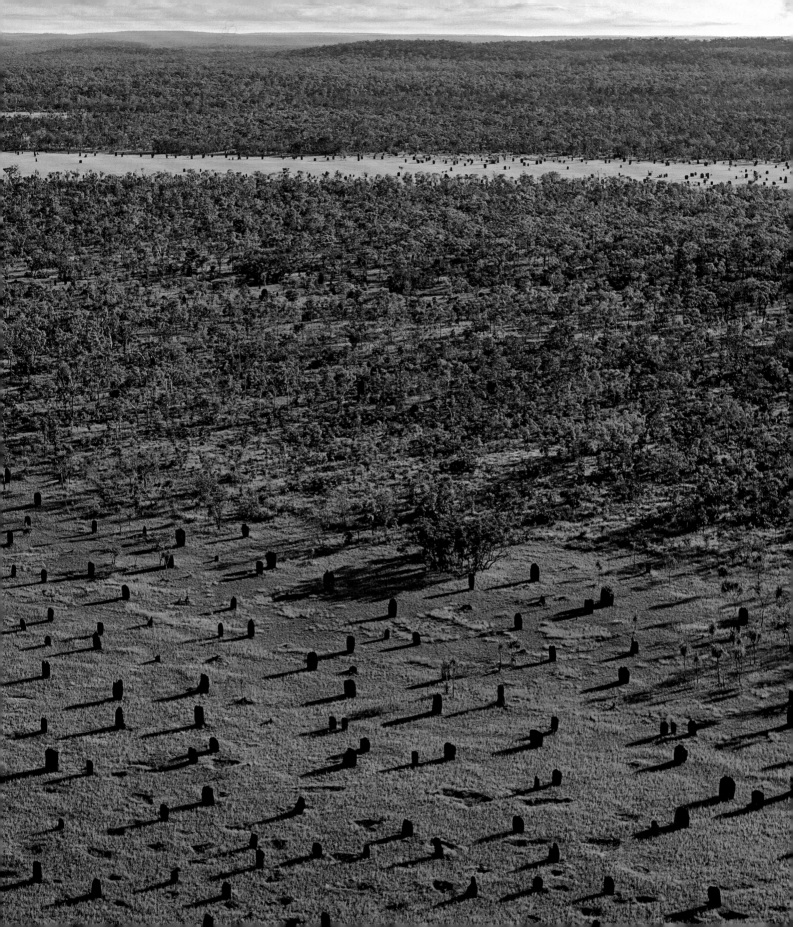

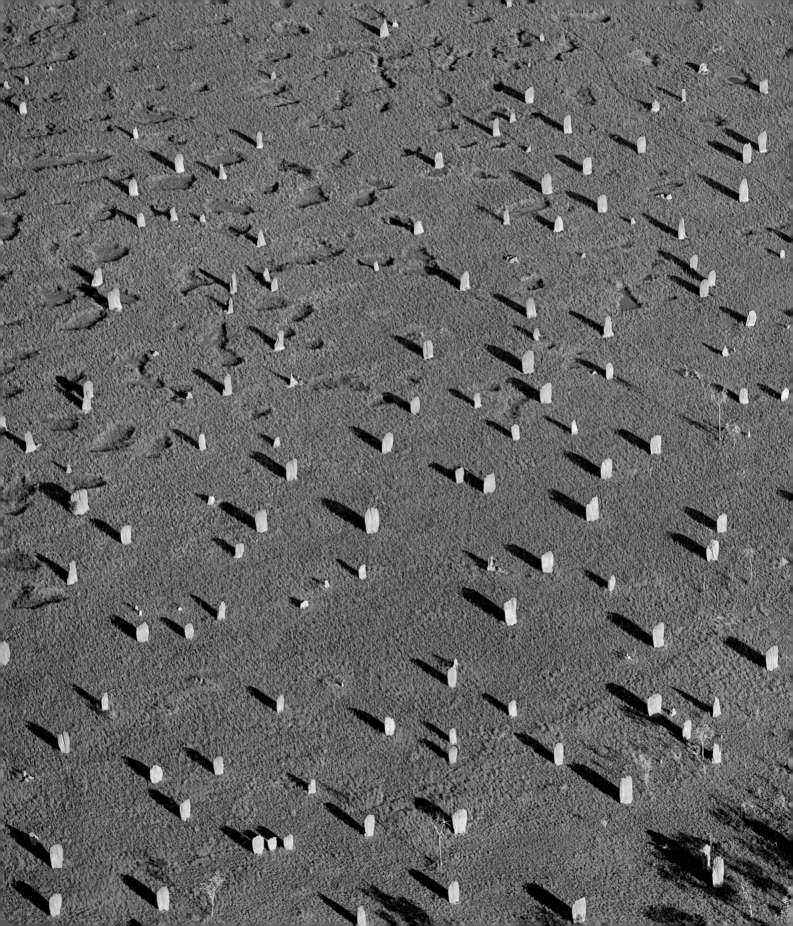

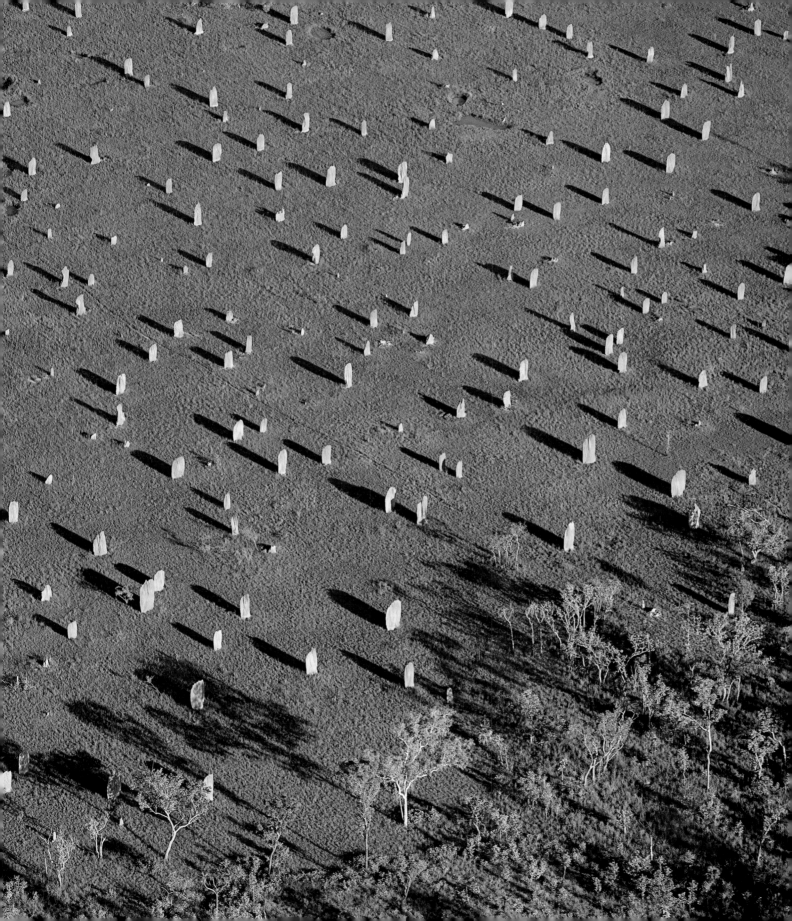

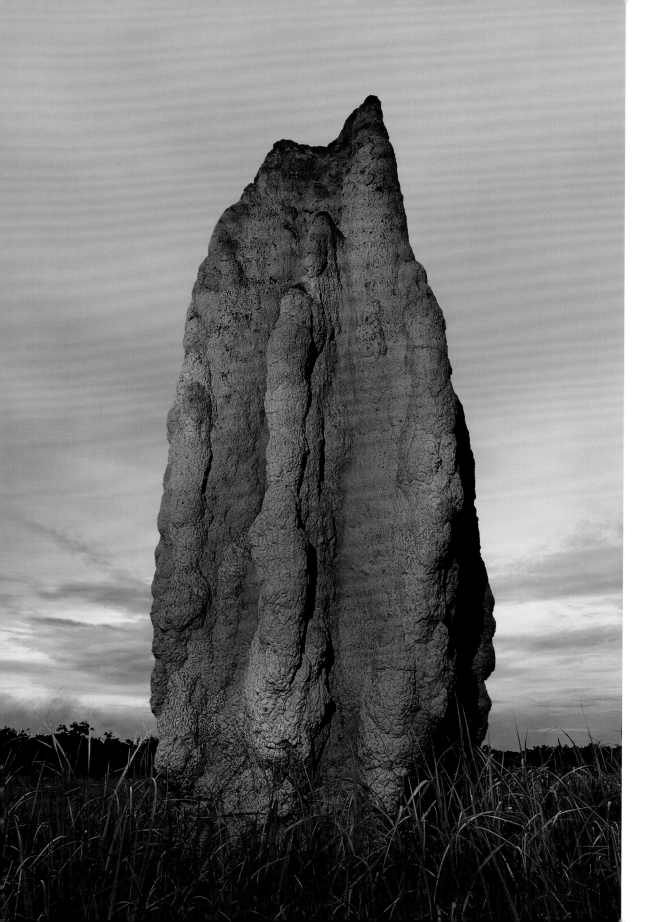

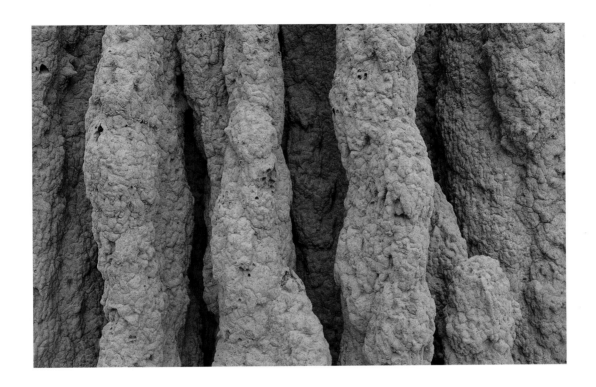

The towers of Australian spinifex termites reach
heights of more than twenty feet (six meters), and
definitely belong among the most spectacular animal
constructions in the world. A single structure can
accommodate two to three million termites. The
chimney-like form of the termite hill also serves
as part of an ingenious ventilation system that main-
tains an ideal internal temperature of approximately
86°F (30°C).

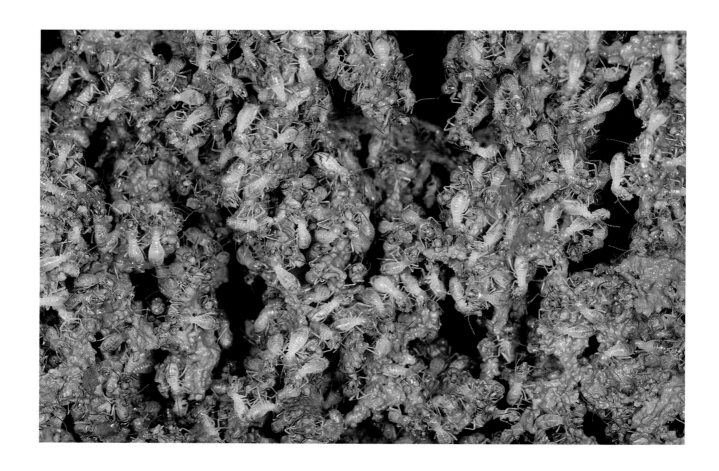

It is only possible for the tiny termites to build their gigantic constructions with a well-organized communal effort. Masses of workers are continually occupied with extending the termite hill, conducting alterations, or making repairs.

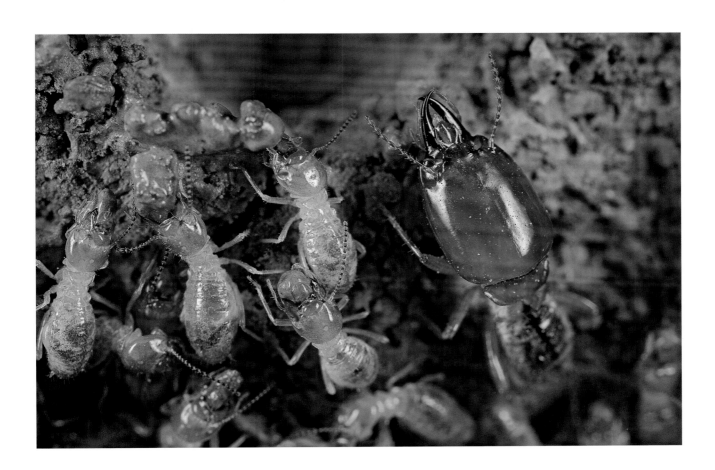

Small balls, consisting of a mix of earth and saliva, are brought by the workers to extend the construction. Soldier ants equipped with gigantic heads and well-fortified pincers watch over the workers.

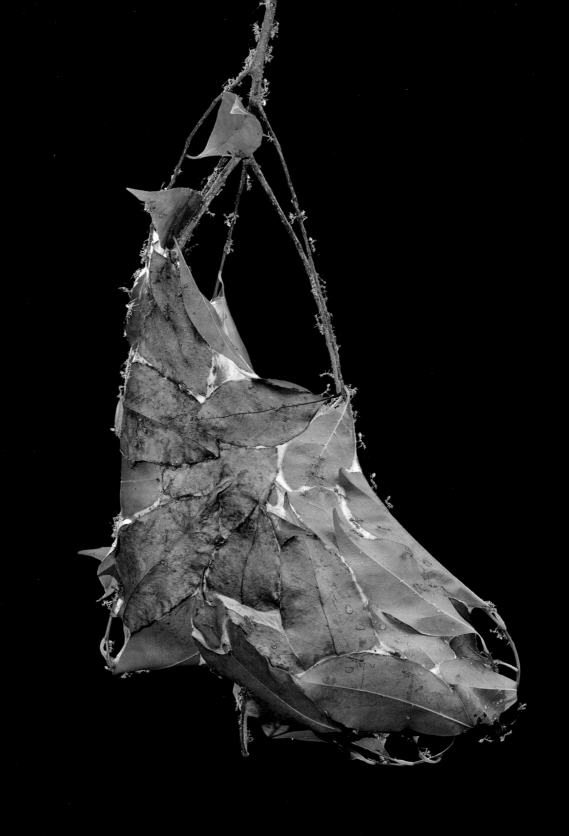

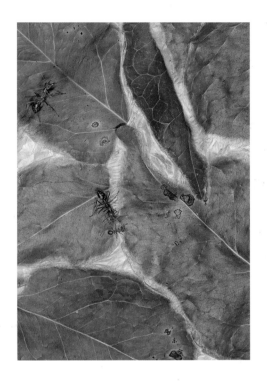

Australian weaver ants build their nests from leaves.
Several of these artistic creations often hang
together in a tree. For the nest construction, the
adult builders pull together leaves with their pincers
(see p. 81) and then interweave them with silk
threads that are produced by their larvae. The
complete construction of a weaver ant nest takes
approximately twenty-four hours.

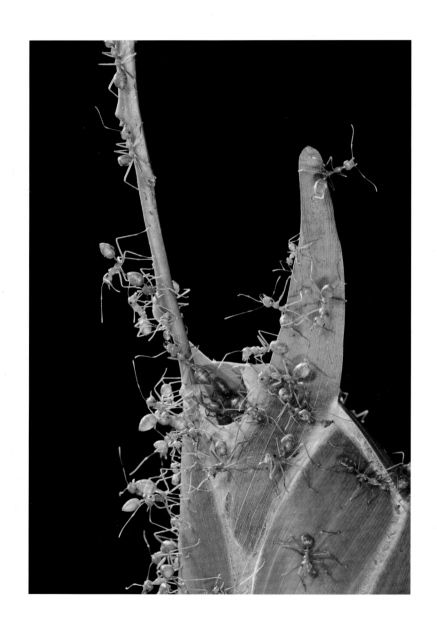

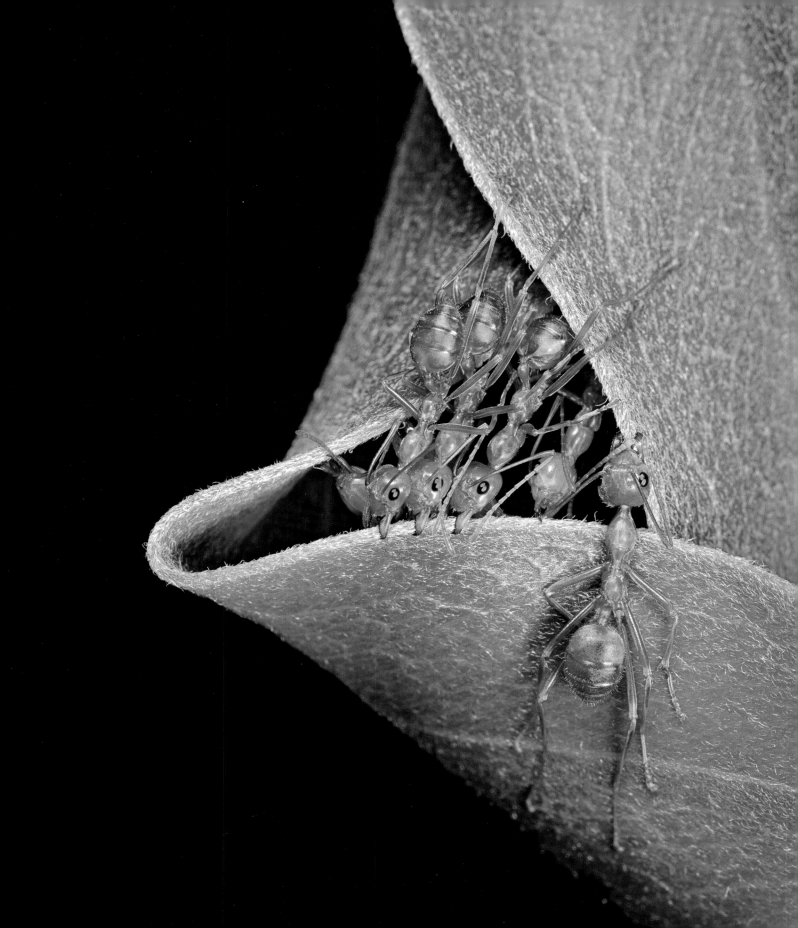

"Firmly bricked in the earth"—to quote the poet Friedrich Schiller—could be the motto of the termites. Termites are not ants; in fact, the closest relative of the termite is the cockroach—and this should be said without throwing the termite into the same pot as that oft-despised hexapod. Colonies consist of roughly equal amounts of male and female termites and one royal couple. The foundation of a new fortress begins with the nuptial flight of the royal couple. Initially, they alone establish the structural engineering, begin to create corridors and chambers in the earth, and build pyramids, towers, and plates upward. Soil is their principal building material, and they use their own excrement as a binding agent, Once dried in the sun, the resulting structure is a concrete-solid mass that would require the grave claws, muscular strength, and steadfast patience of an aardvark to destroy. The rapidly growing multitude of workers erect structures three feet (one meter) high and three feet (one meter) thick. The architecture of these facilities is characteristic of the species. Especially striking are specialties such as the board-shaped appearance and the precisely positioned nests of the compass termite, which are

optimally placed to take into account the daily pattern of the sun. Tricky architectural measures also provide the inside of these castles with an ideal climate. Through a system of ducts and chimneys, which are large enough to provide a hiding place for smaller mammals and snakes, dirty air is exhausted and fresh air is supplied continually.

We reach the summit of animal architectural skill with honeybees. They not only build honeycomb cells in a uniformity that is breathtaking, and use materials that are exclusively from their own resources, but they also create a climate-controlled world for their honeycombs and their inhabitants in which all of the important factors are finely regulated. Wax is generated by young bees from glands on the belly side of their abdomen. When the little ones excrete the wax as sweat, it is carried to the hive by the construction bees. The German astronomer Johannes Kepler was so impressed by the precision of these assembled cells that he supposed that bees had mathematical minds. In fact, honeybees generate these architectural wonders with a magnificent technique that doesn't use mathematical formulas.

First, round cells, closely packed, are formed on the building site. The heater bees then enter the cells and amp up their body heat, which can rise higher than 104°F (40°C), whereupon the wax walls begin to melt and become malleable enough for the bees to work with. The completed honeycombs are true multifunctional units. They serve as shelters, production plants for turning nectar into honey, storage space for honey and pollen, breeding grounds, a communication network for the transmission of the slightest vibrations in the dark beehive, and information storage. When the bees change location, they place their specific scent on a single honeycomb, which becomes an orientating landmark for the bees and the first defensive line against germs.

The bees do not have a complicated temperature-control engineering system, but nevertheless, they succeed in keeping the brood nest nearly at human body temperature. Heater bees bring their flight muscles to a momentum that then delivers warmth to pupae in the brood. If it is too hot in the summer, the water collector bees snap into action and wet the walls of the honeycombs, whereupon the wa-ter's evaporation provides cooling. Ventilating bees work in close tandem by flapping their wings and generating a small cooling breeze. If one looks at the honeycomb as the largest organ of the honeybees, the regulation of the nest's interior can be compared with the maintenance of human bodily functions. In our bodies, certain control mechanisms ensure that our body temperature and blood sugar levels remain generally consistent; in quite a similar manner, the bees and the characteristics of the honeycombs create a stable internal environment of the superorganism bee colony.

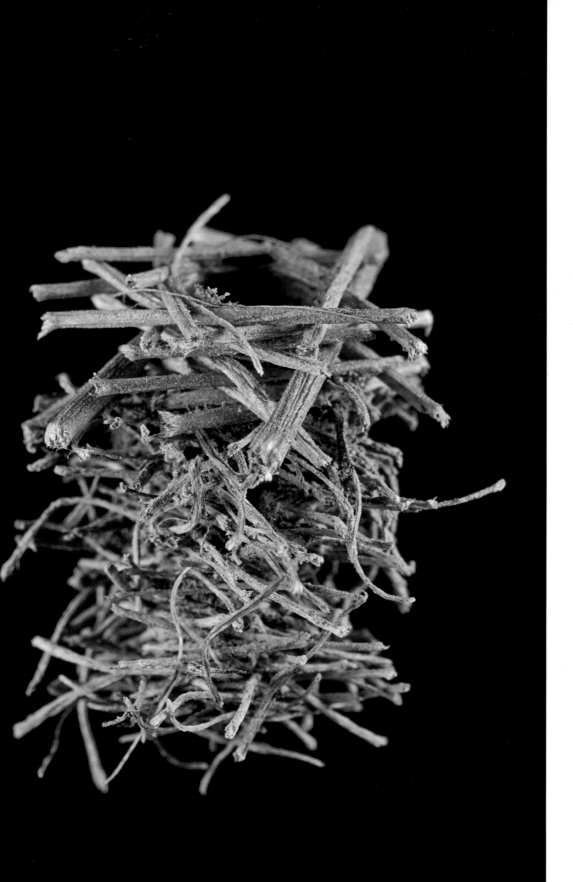

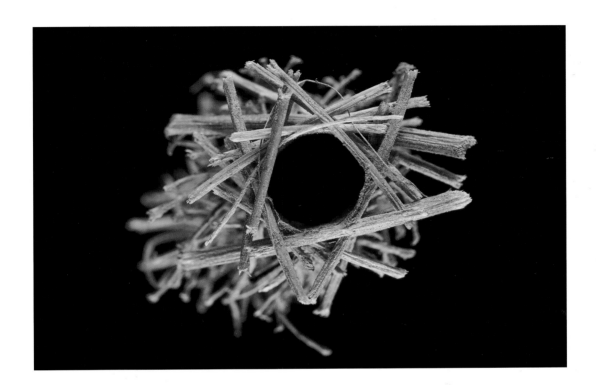

Few people would believe an insect larva could construct such extravagant dwellings as the ones shown on these and the following pages. The larva of the caddis fly builds a case around itself for the protection of its soft body. This so-called casing protects the creature in the water and consists of materials that vary according to species and habitat.

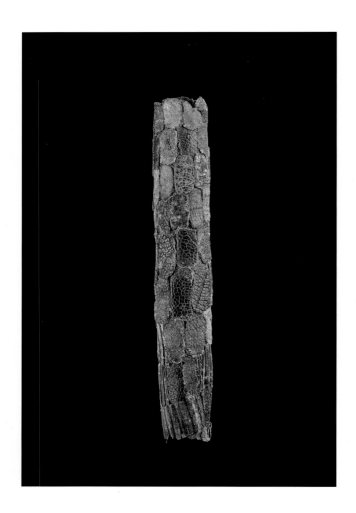

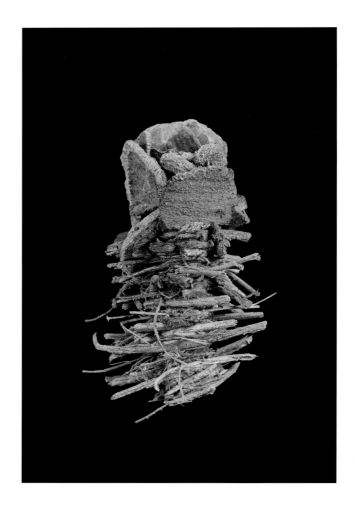

The building materials are bonded together with the help of a secretion that is emitted from glands in the caddis fly's head. This "superglue" is similar to the chrysalis silk of butterflies.

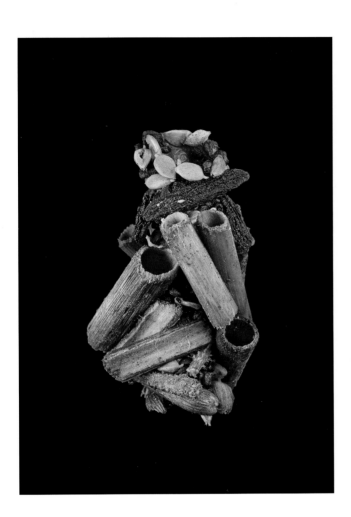

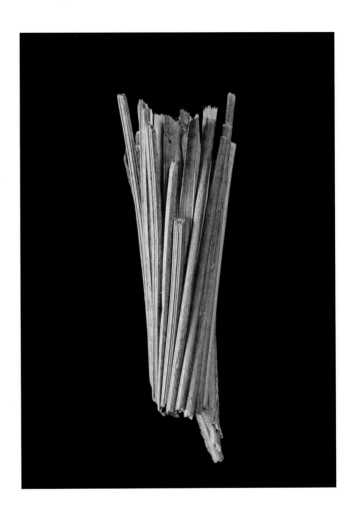

The dwelling also grows with the size of the larva. The front end is extended to accommodate the larva's size while the rear end is bitten off, little by little, by many other species.

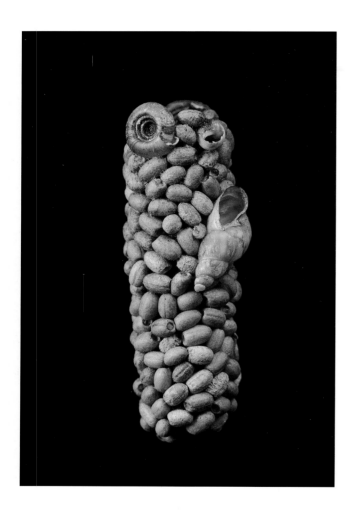 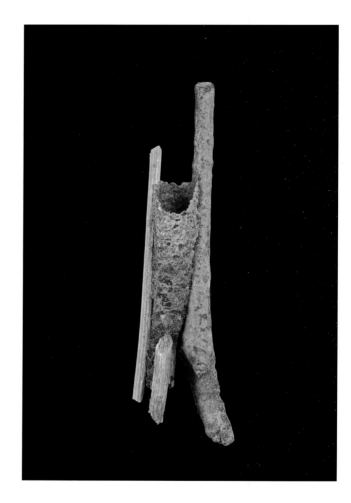

Various materials are patched together for the case.
Plant material is frequently used, but pebbles or snail
shells can also be incorporated.

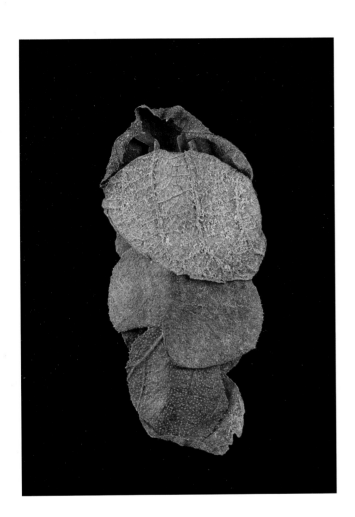
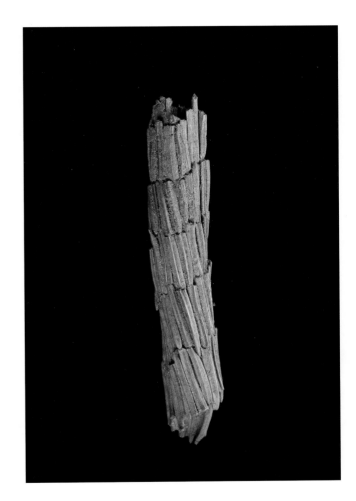

Today, approximately thirteen thousand different caddis fly species have been identified. Of these, more than 1,200 species live in Europe alone. Their cases are often only a few millimeters long.

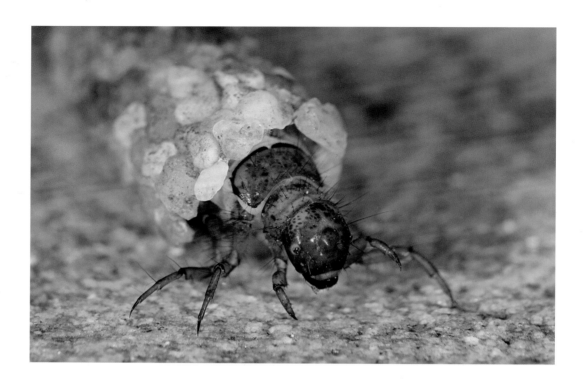

Caddis fly larvae primarily feed on plant debris,
though some types can be considered predatory. Up
to the pupal stage, the larva must molt five times.
This is followed by a pupal rest of several weeks until
the winged insect hatches out of the case and begins
its life on land.

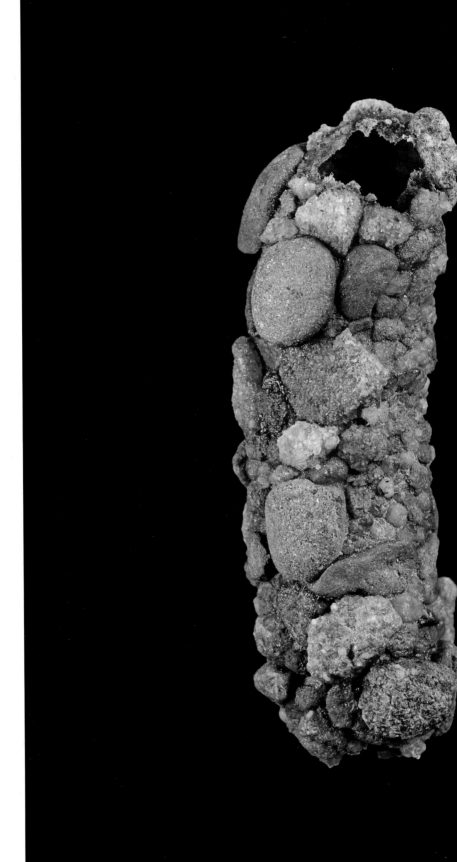

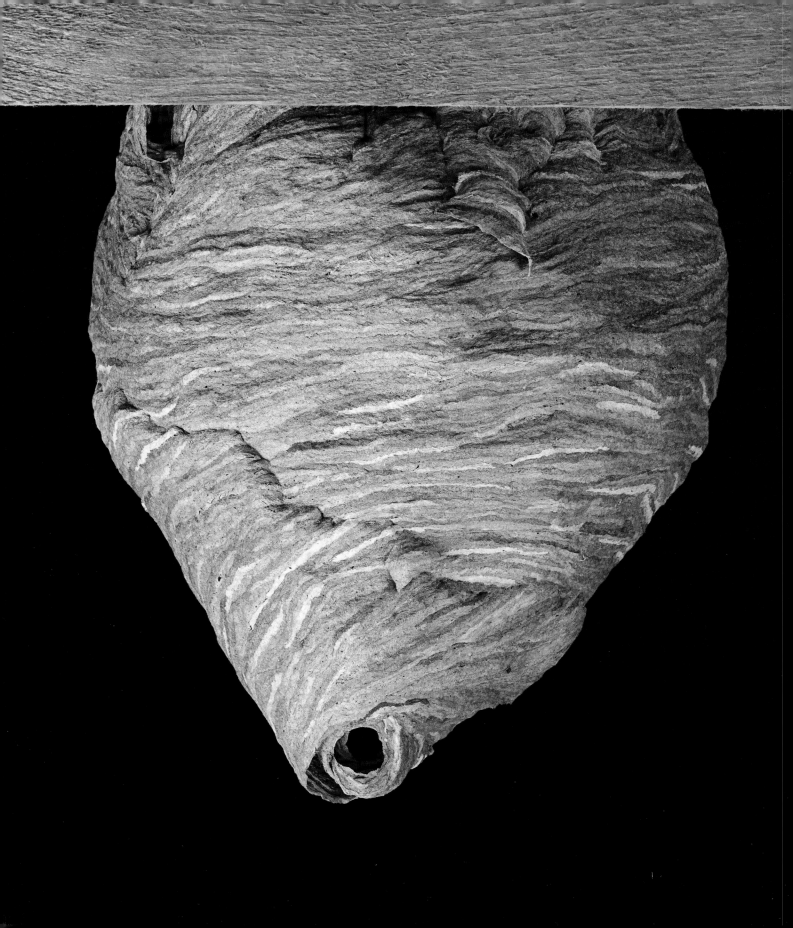

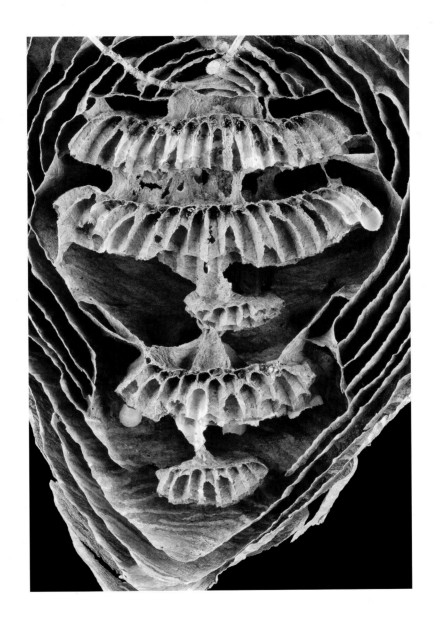

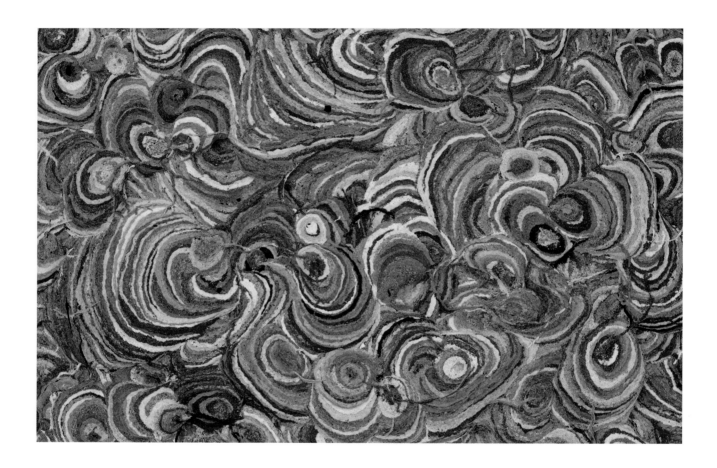

The median wasp, native to Europe, builds its nest
openly in bushes or in eaves.

(pp. 92–93)
The paperlike construction reaches a maximum size of
approximately twelve inches (thirty centimeters). The
external cover consists of closed air pockets. Three
to six honeycomb levels, with up to 1,800 cells, are
incorporated inside.

Wasps chew up rotten and dry wood for the construction of their housing. The nest varies in structure and color depending on the wasp's architectural style and the type of wood used.

On the left, the nest surface of a common wasp; above, that of a median wasp.

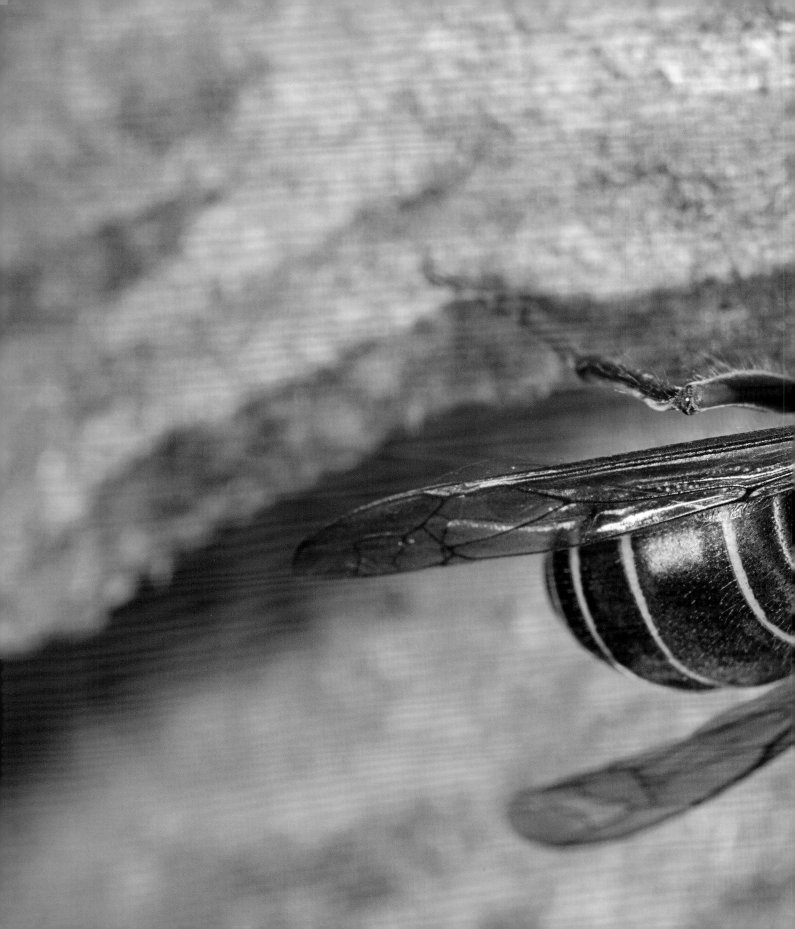

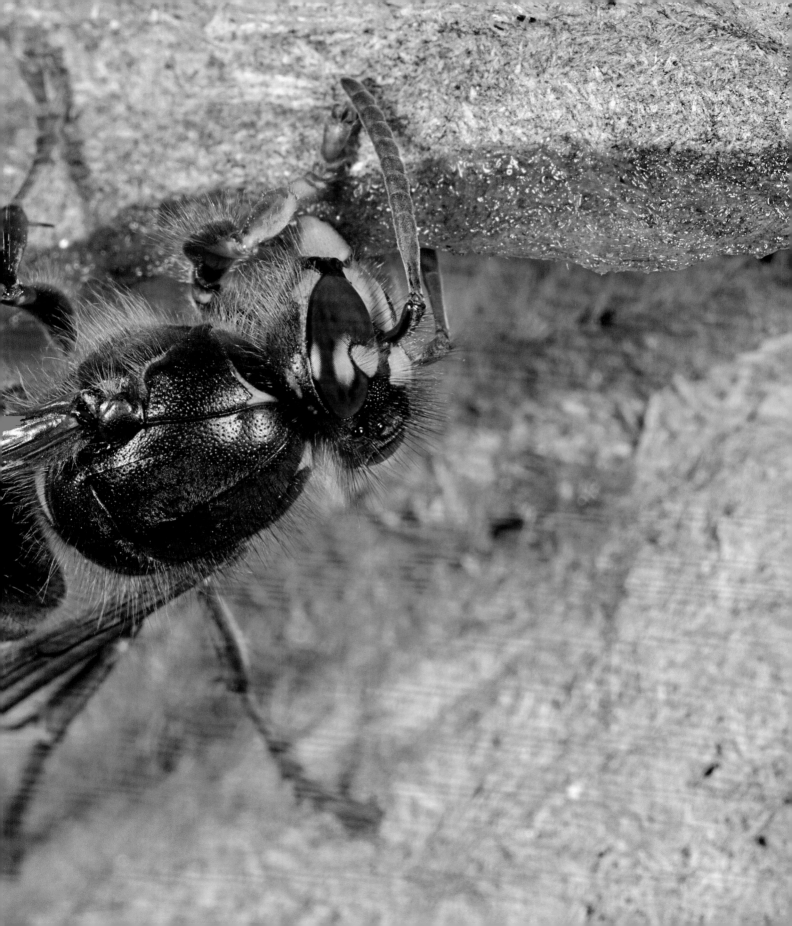

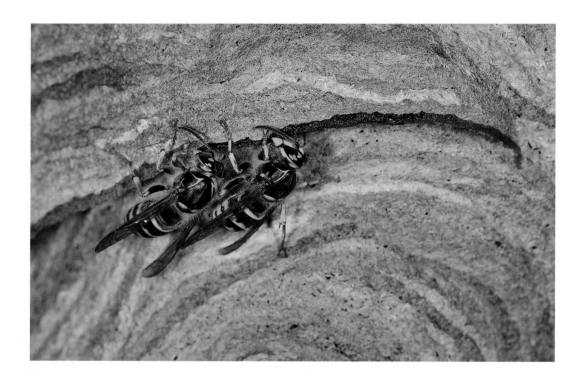

The median wasp transports the masticated wood
to the nest with its mouthparts. The material of
the outer shell is positioned in long lines in order to
extend the construction. Median wasps primarily
use poplar wood for nest building.

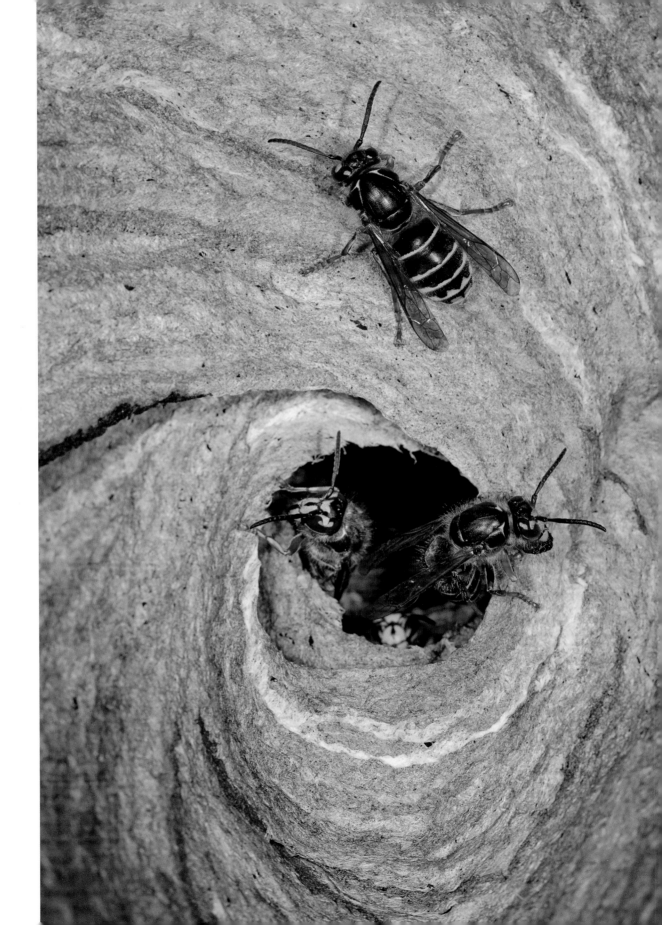

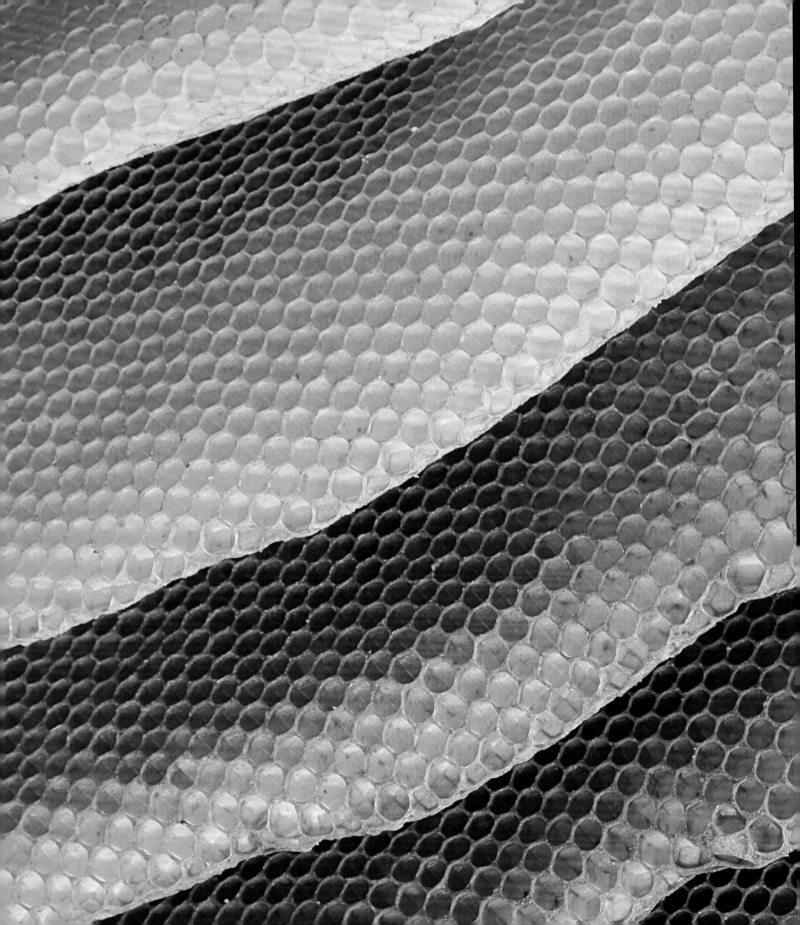

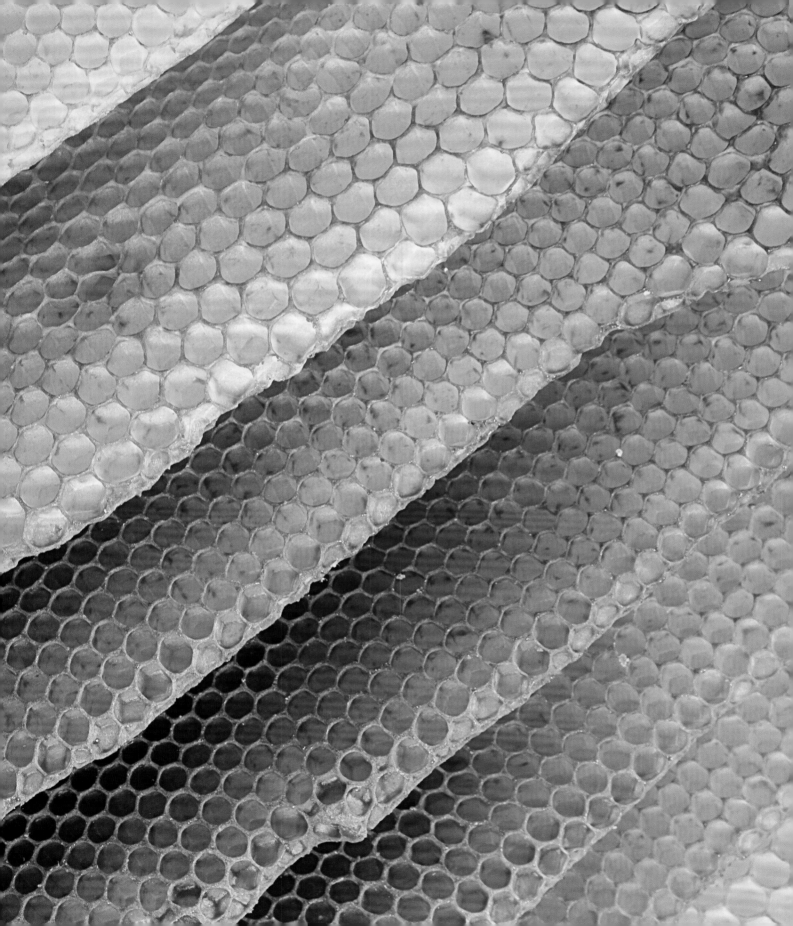

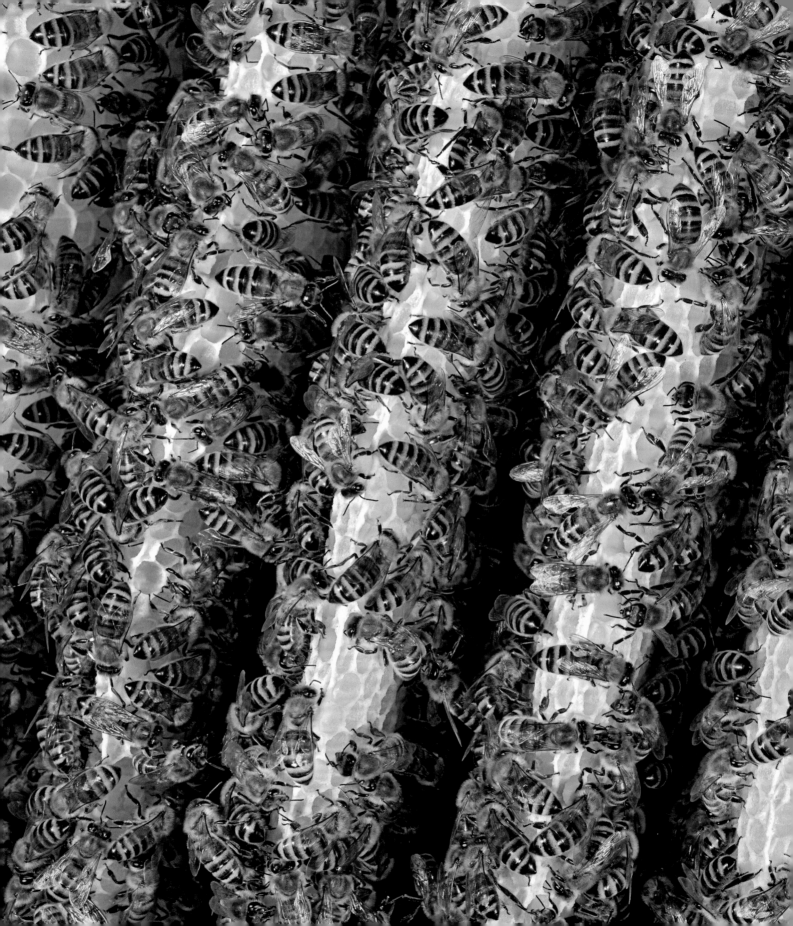

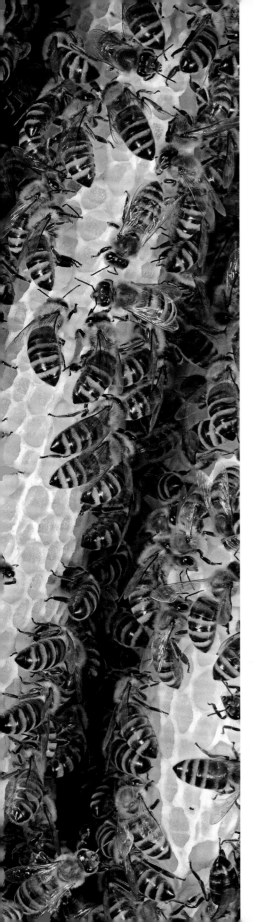

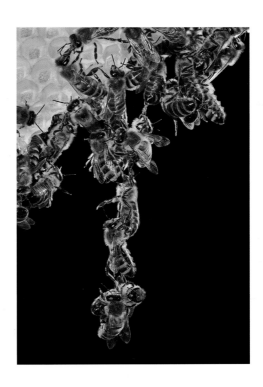

Honeybees generate their building material them-
selves. Each worker bee has eight glands that secrete
wax onto its abdomen. The wax forms into scales
that eventually flake off, which the bees can then use
to build their honeycombs. Distance is maintained
between the parallel-hanging honeycombs, enabling
the bees to easily move between the combs when
flying packed closely together. The construction of the
precisely hexagonal honeycomb cells is a masterful
architectural achievement.

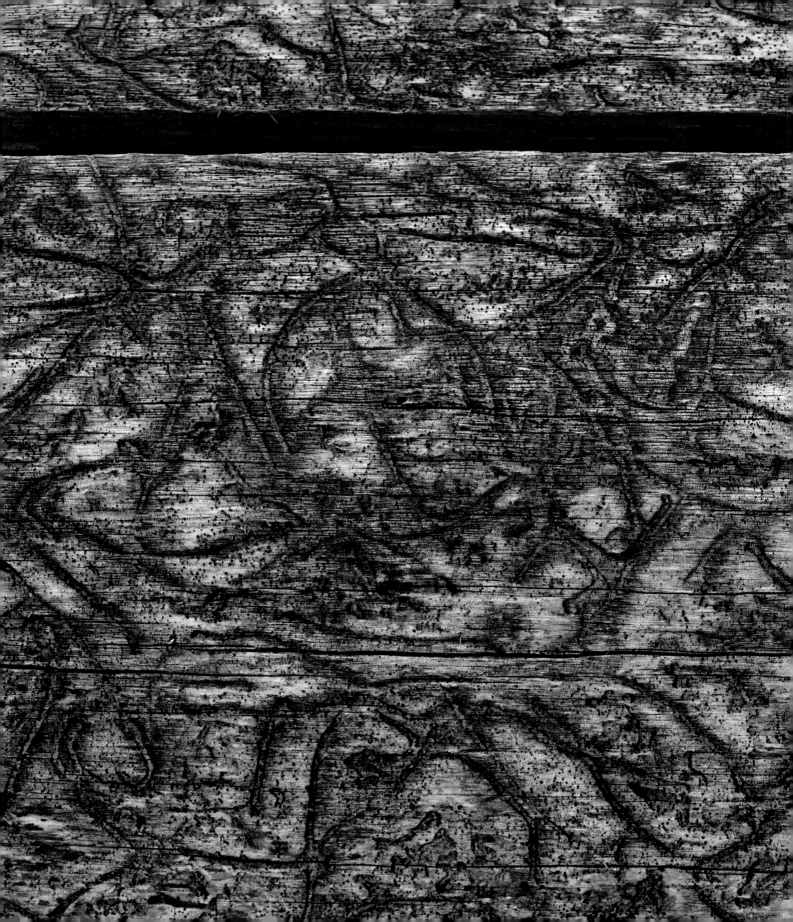

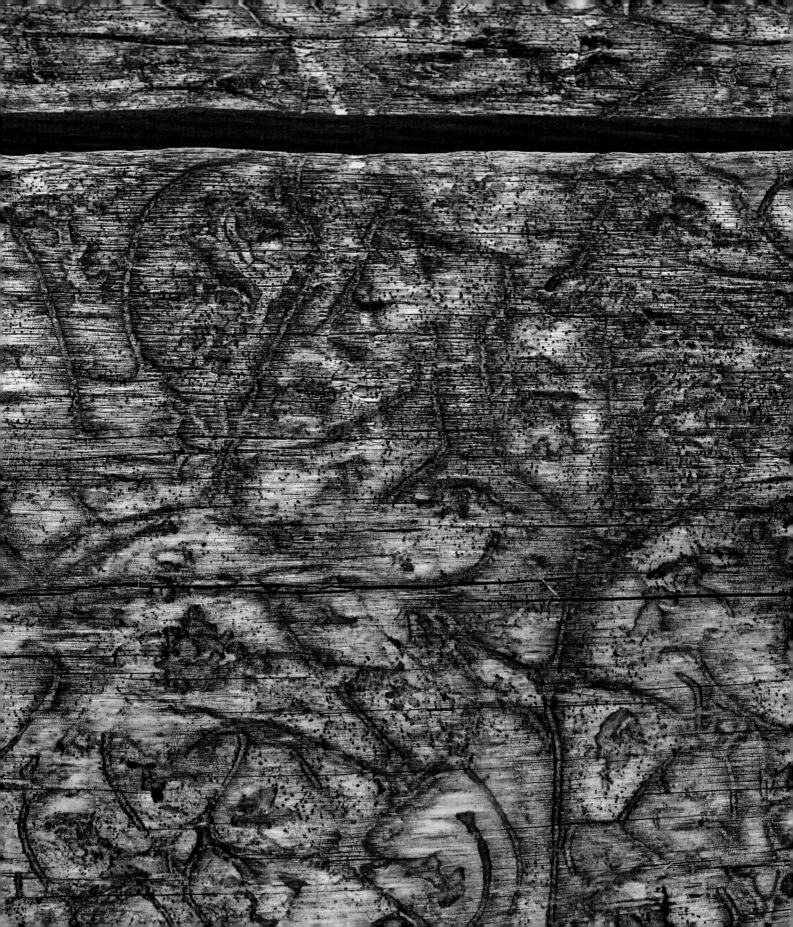

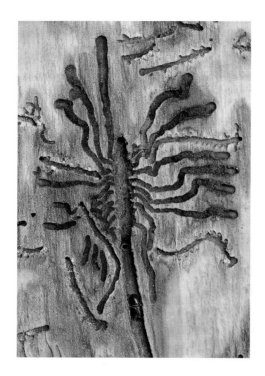

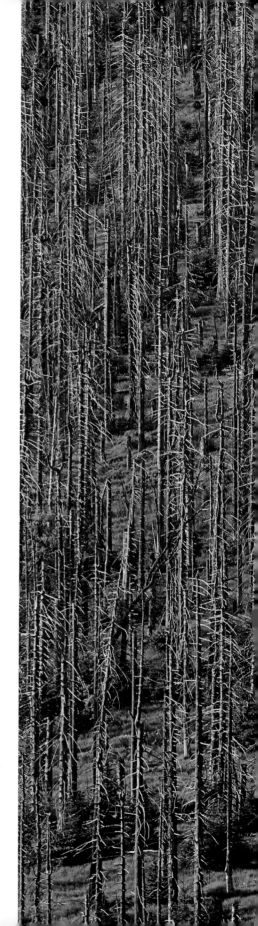

The galleries bark beetle larvae form as they eat
through the bark leave a clear picture of their feeding
habits. (See also pp. 104–5.)

The small beetle larvae thus destroy the inner bark
of a tree, which is important for the transportation
of the tree's nutrients. Complete stands of trees can
die as a result of a massive increase in the population
of bark beetles, as occurred in the Bavarian Forest.
However, over time, new trees grew in their place,
and the forest was regenerated.

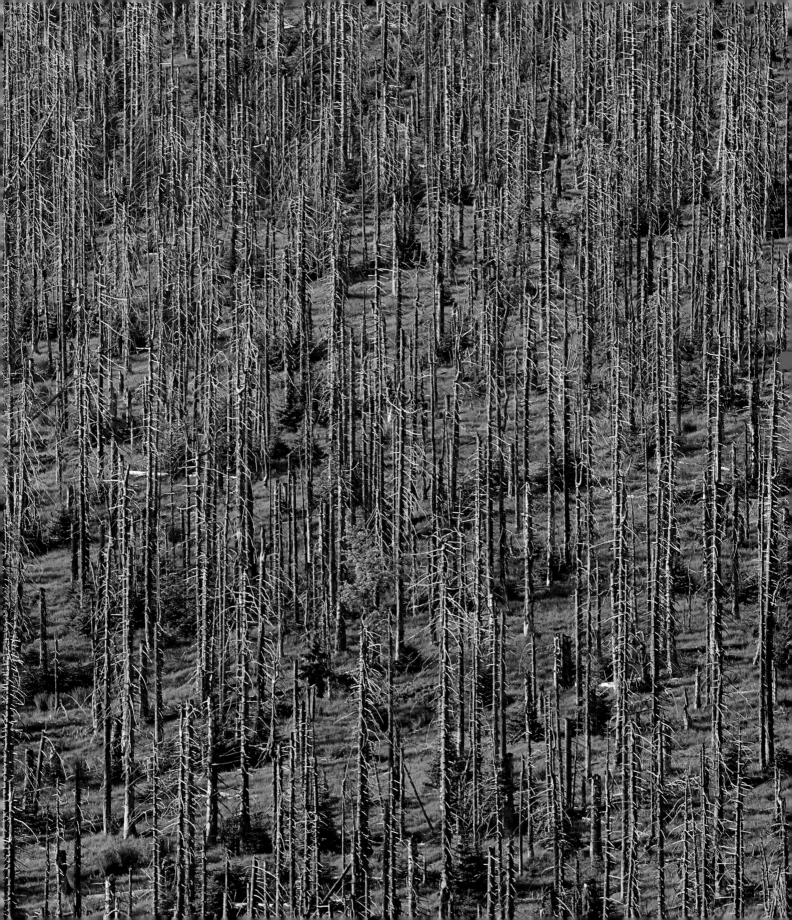

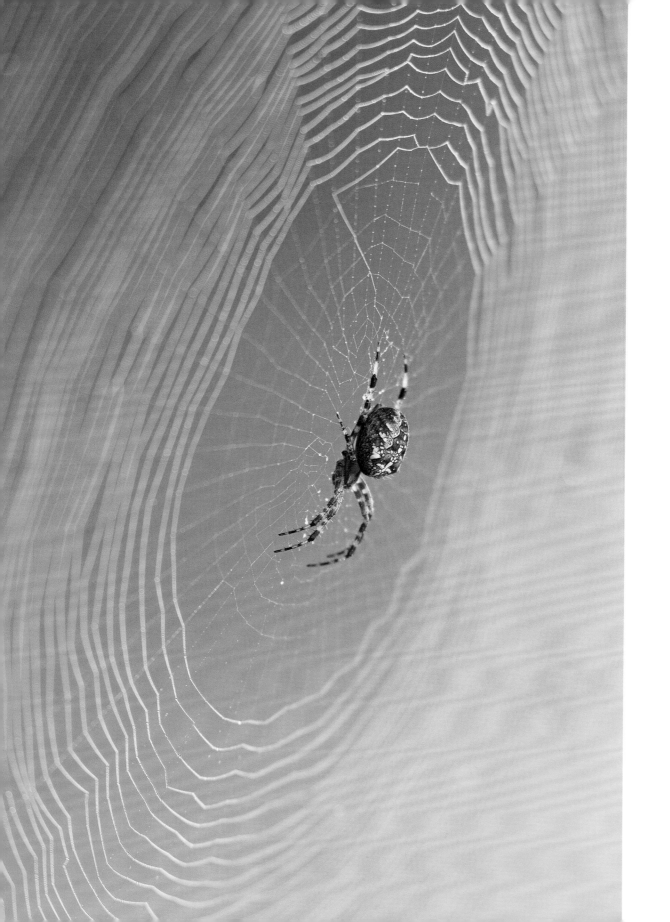

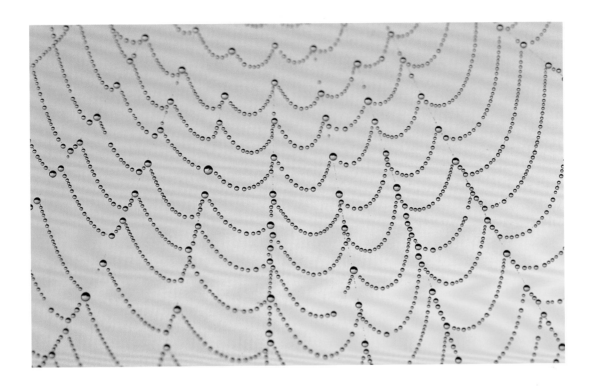

The garden cross spider fastens its large orblike web near the ground. The web often consists of more than thirty radii and has a closely woven hub. Adult spiders can weave webs with a diameter of up to twenty inches (fifty centimeters). As many as 1,500 connection points can be noted in the design, which has a preestablished blueprint. In the morning dew, the spiderwebs seem as though they are laden with small glass balls.

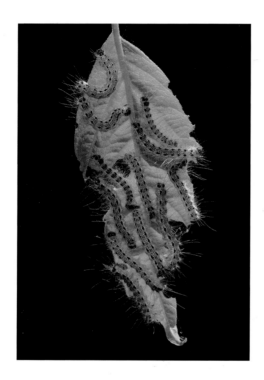

To protect against predators, the group-living larvae
of the European buff-tip moth build a web around
their fodder plant. After they have eaten all of the
leaves within the protective shell, the larvae move on
to the next branch.

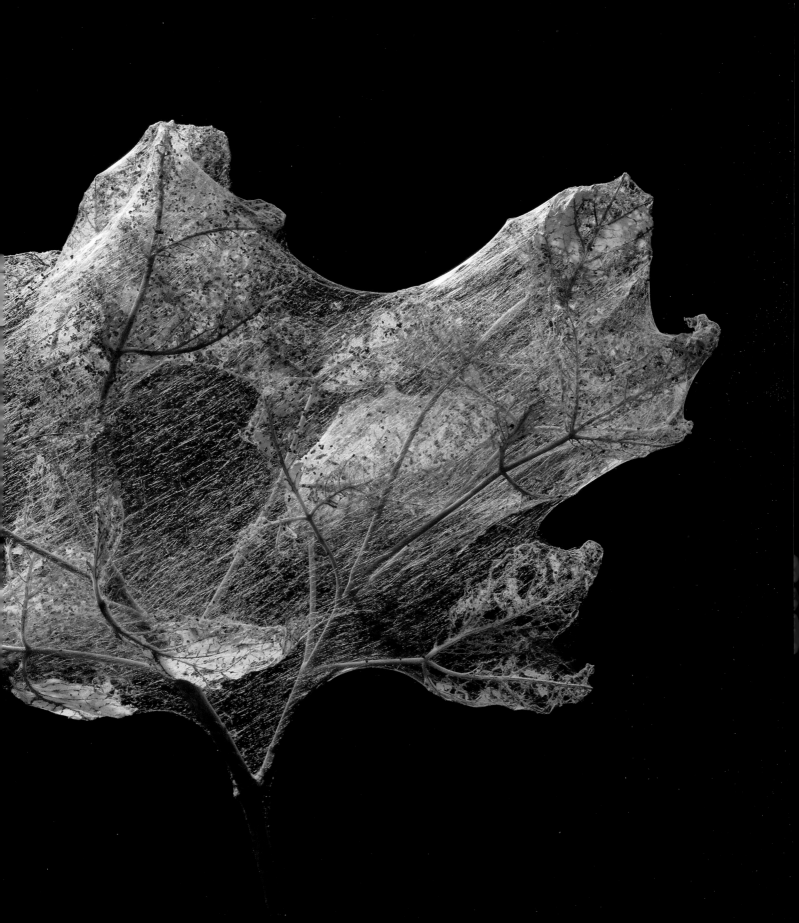

3

MAMMALS

LANDSCAPE
ARCHITECTS

MAMMALS ARE GENERALLY NOT AMONG THE GRAND MASTERS OF NEST BUILDING, BUT THERE ARE EXCEPTIONS

One cannot truly designate nest building as a typical characteristic of mammals. The many purposes that nests serve for other animal groups, and a few mammals, are achieved by most mammals through physiological and behavioral adjustments. A constant body temperature regulated by insulating fur, an embryonic development that takes place inside the protective womb, and a long bonding period of the young with their mothers renders the nest unnecessary. As a result, mammals are generally not included among the grand masters of nest building. Simple padded-out troughs in the soil form the nurseries of hares. Other mammal species, such as the hare's close relative, the rabbit, make underground cave systems for their protection that usually have comfortably padded chambers at their centers. Not only are the underground chambers and duct systems functional, but also they can serve as a hunting and gathering ground for food. During their tunneling, naked mole rats come across nutritious root tubers, moles stumble upon earthworms, and insects find larvae to eat. In contrast, chimpanzees and orangutans build their nests high up in trees. Night after night, they bow the branches together and weave them into sleeping nests that they then comfortably cushion with foliage.

These examples would almost entirely encompass the nest-building techniques of mammals were it not for harvest mice and beavers. Both of these species belong to the rodent family, whose bodies are ideal for building nests: They have astonishingly agile hands for gripping and holding, as well as incisors in their upper and lower jaws for cutting and trimming, which are the defining characteristic of their order.

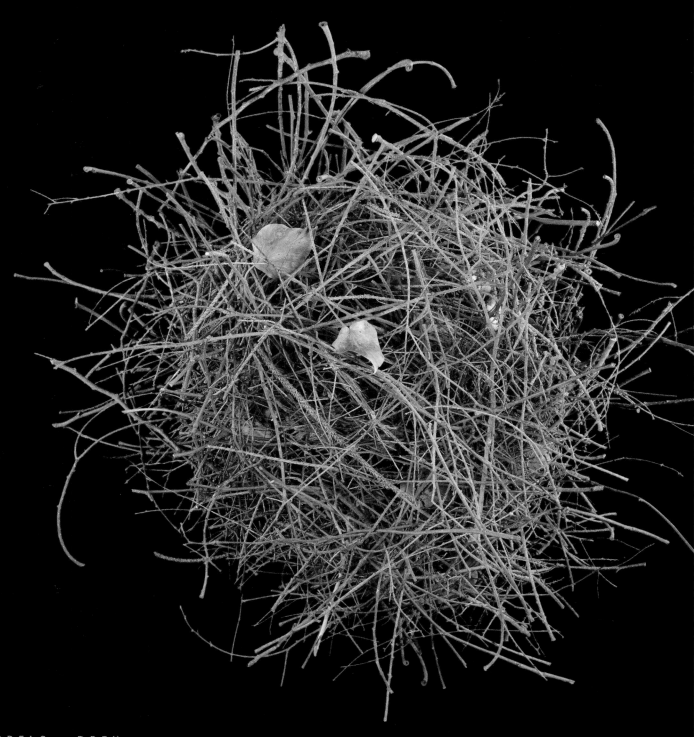

SQUIRRELS - DREY
BRANCHES, LEAVES, FEATHERS

Weighing in at five grams (0.17 ounces), the harvest mouse (*Micromys minutus*) is the absolute light-weight among the mammals. These mice are most at home in high grass, grain stocks, or reed beds. Equipped with a long prehensile tail for climbing, they have all of the prerequisites to exist in a world of long, thin blades of grass and grain stalks. As a result, they can utilize these special surroundings to raise their young. The mouse builds a ball-shaped nest of intertwined grass leaves approximately three feet (one meter) high, using the tall stalks as both supports and spacers from the ground. The tiny builder finds these leaves for its nest in abundance in a meadow or grain field. With tiny, razor-sharp incisors, the harvest mouse can split the leaves lengthwise to render long, tear-resistant, extremely entwinable threads. A round, narrow opening on the side of the ball is the only entrance to the nest. The inside of the ball is softly padded with even more finely split and shorter pieces of properly trimmed grass. The work is completed in a few hours or, at most, two to eight days. On average, three to eight harvest mice pups can lie warmly and dryly in this nursery and are perfectly protected from shock in the event that a storm plays havoc on the swaying

home. Their food, consisting of grain, insects, and the ripe ears at the end of the carrier stalks of the nest, is at their front door so that the mice are spared having to venture out onto dangerous and wide-open trails and be away from the nest for long periods of time.

The fact that this home-building strategy is not suitable for larger and heavier mice is understandable. For example, a house mouse weighs less than one ounce (between twenty and twenty-five grams). Because they are featherweights, harvest mice don't need to burrow underground during the summer like other mice, but can build their nests at loftier heights. However, in the winter it is not uncommon for them to withdraw back into burrows as all other mice do. If beavers, which can weigh as much as sixty-six pounds (thirty kilograms), were to live in similarly high nests, they would have to at least use thin tree trunks as a basic scaffolding for the suspension of their dwellings. But beavers are not structural engineering masters like harvest mice; rather, they are hydraulic engineers.

Beavers inhabit lodges. These are either pure earth constructions on high, precipitous embankments, or

they are hidden in a shallow bank area under a huge accumulation of branches, twigs, and small tree stems. For the transportation of large objects, beavers will often create a network of channels that meet at the beaver lodge. The lodge also serves as a secure dwelling in the winter. However, before they withdraw there, the beavers stock up on branches, whose bark will serve as their food during the cold times of the year.

These branch hill lodges are created on the edge of, or even in the midst of, level waters. The entrance to the cauldron-shaped residences always lie underwater. Beavers returning home swim down into the lodge's access canal, which ascends into the dry nest cave. It can even seem that beavers create two superimposed residential caves, making it impossible to imagine a more secure nursery and winter lodging. However, the circumstances are not quite so heavenly. The moated lodge is extremely dependent on the level of the body of water, which is controlled only by inflow and outflow. As a result, lodges do not work over enclosed bodies of water with no inflow such as pools, ponds, and lakes. Beavers can only regulate the water level by building their dams, made of tree trunks and branches, over flowing water. Beavers maintain and expand their dams and lodges, keeping them in good condition for many generations. The longest-known beaver dam possessed an impressive length of 765 yards (seven hundred meters) and could bear the weight of a horse and rider. Beavers are landscape architects in the truest sense. The biotopes that originate from their hydraulic engineering activities are greatly expanded, and it is only through their beaver-regulated water levels that reliable living spaces are offered to water- and marsh-inhabiting plants and animals.

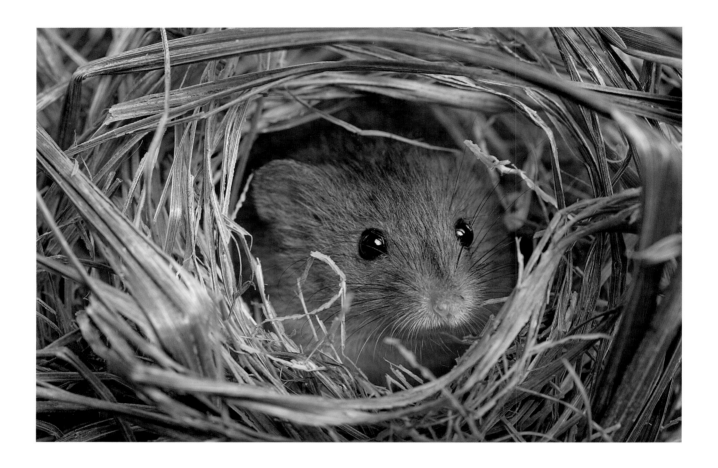

Eurasian harvest mice design and build their nests to be well hidden in high grass. The tiny creatures twist blades of grass together with great talent until they form a ball. The ball nest is securely connected to the surrounding vegetation. The small rodents pad the inside with spliced fine grass.

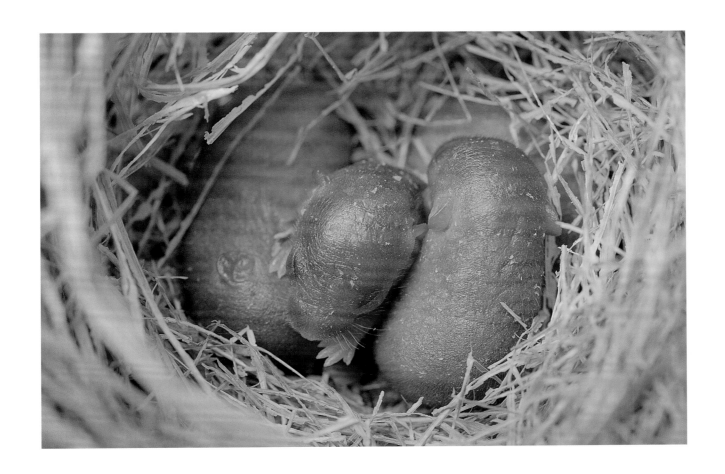

On average, a litter of harvest mice consists of three to eight pups. The still-hairless newborns are tiny and weigh just 0.03 ounces (one gram). After a good two weeks, they will be fully grown and weaned, and will have left the nest.

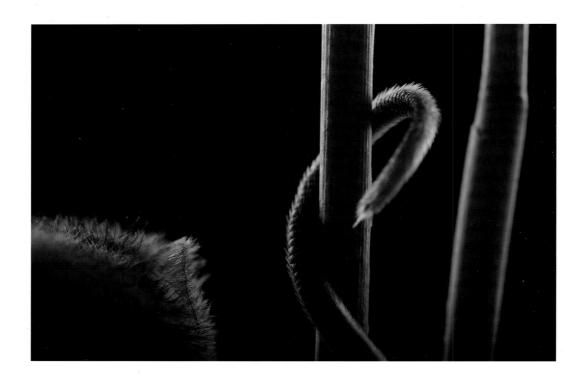

The building of a nest in a forest of grass and reed stems
requires a great deal of dexterity in movement. The unusually
long prehensile tail of the harvest mouse allows the mouse
to build with the necessary agility and precision.

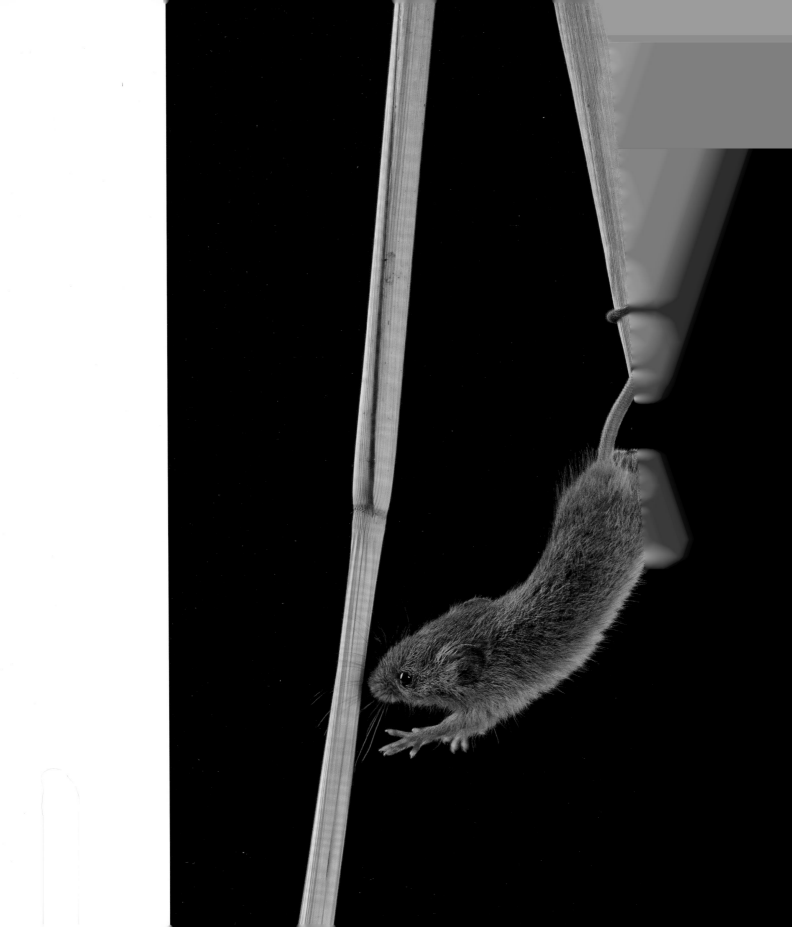

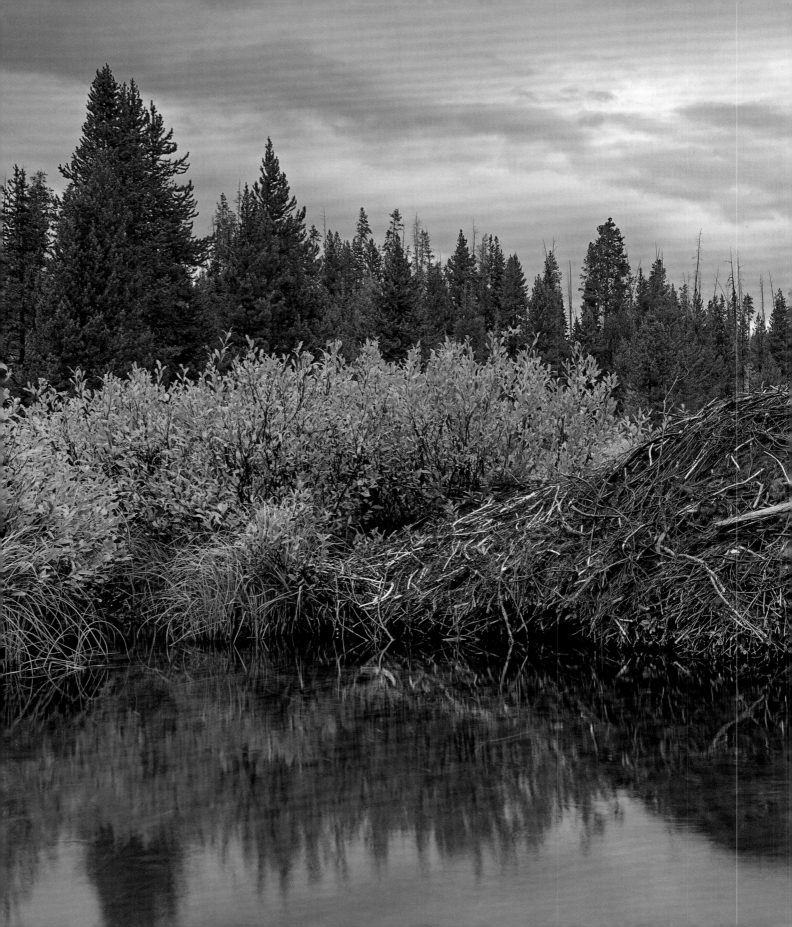

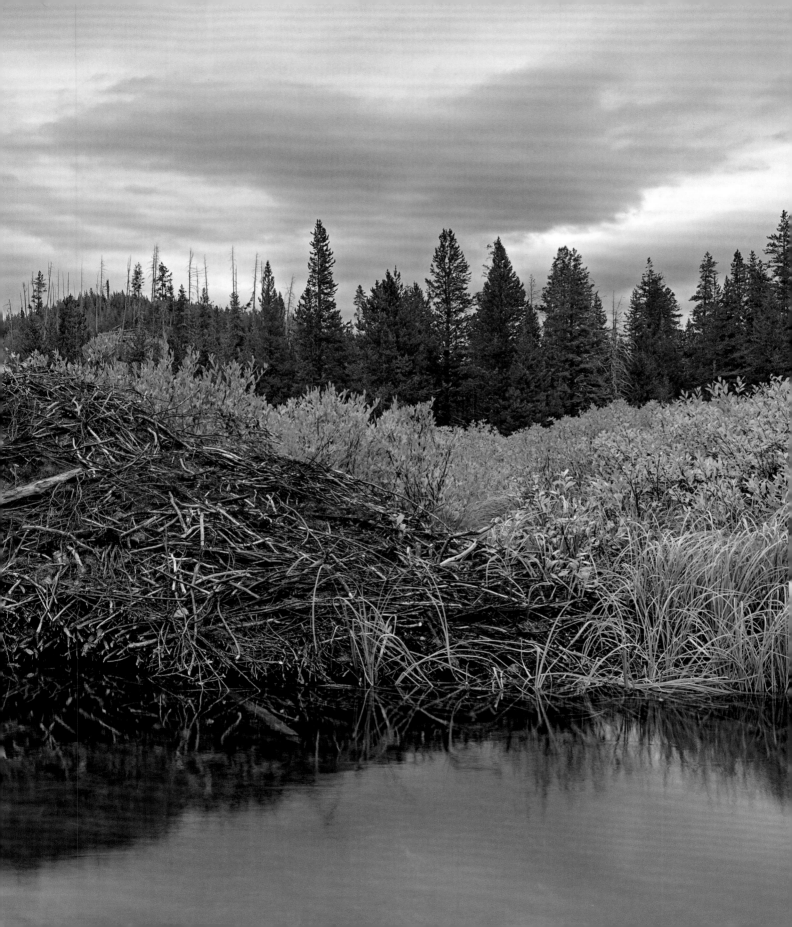

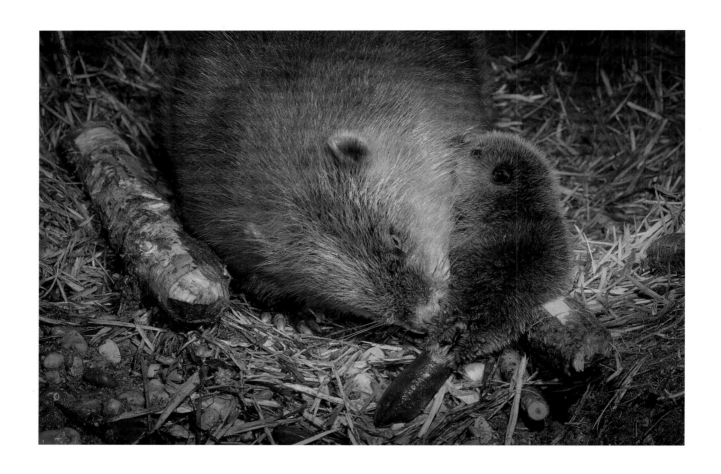

(pp. 122–25)

Beavers develop their own living space through
their building activities. The lodge is accessible
only through an underwater entrance. It offers
the animals protection against enemies, cold, and
heat, and is a sleeping area and birthplace for the
younger generations.

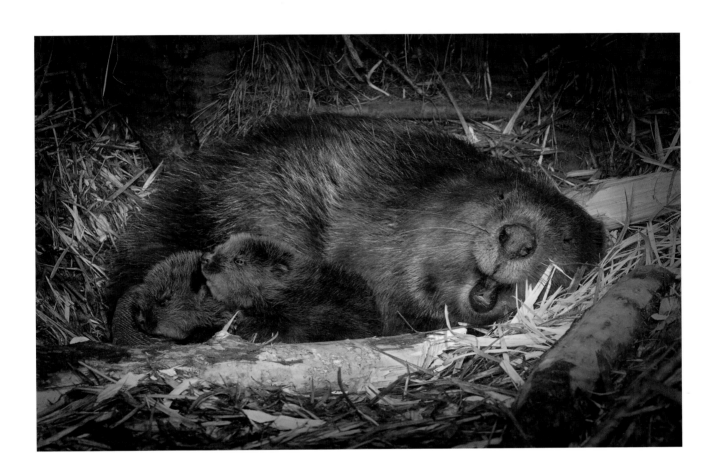

Beavers regulate the water level and the number of
water surfaces in their area with dams (see p. 126).
In doing so, they protect the entrance of the lodge,
create new food sources, and make the transportation
of food and building materials easier on themselves.
Branches, trunks, and mud in particular are used in
the dam construction.

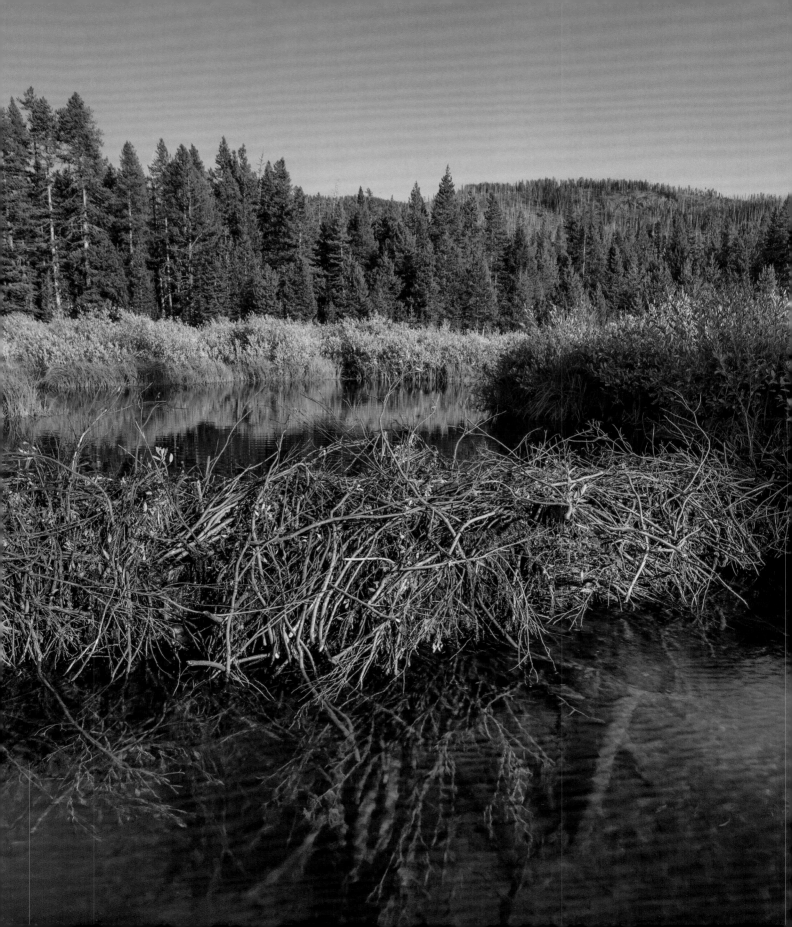

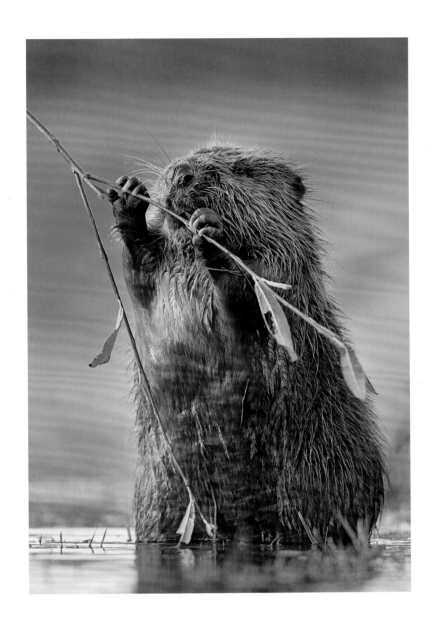

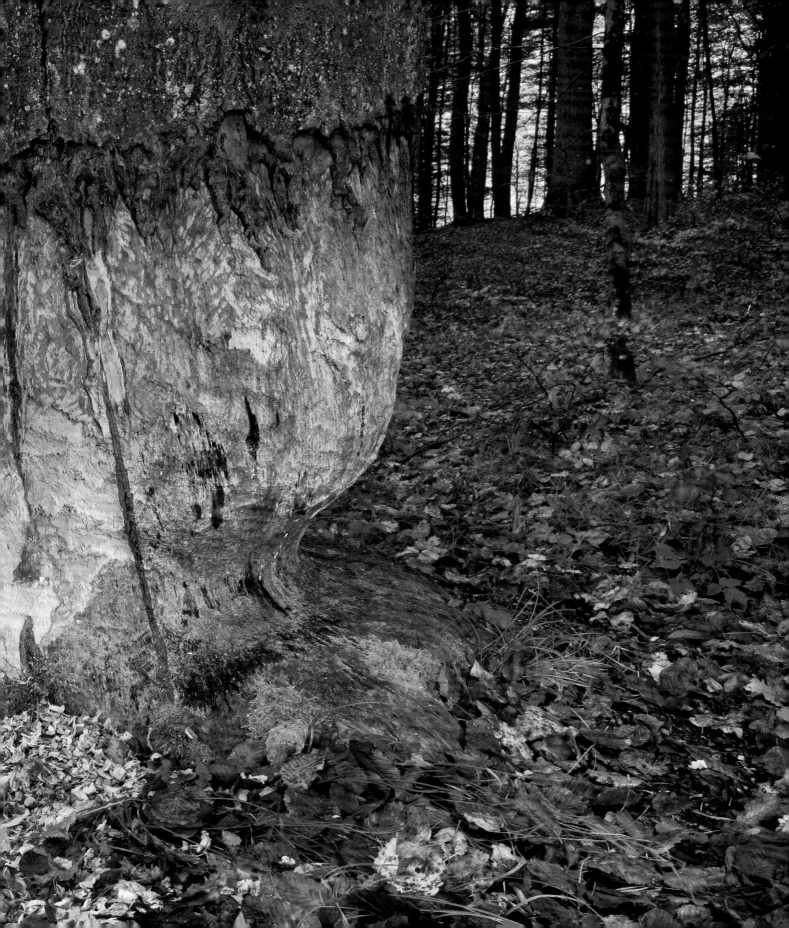

4

CALCIFIED MASTER BUILDERS

SEA ORGANISMS HAVE BEEN BUILDING THEIR BODY SHELLS FROM LIME FOR ROUGHLY SIX HUNDRED MILLION YEARS

Lime—which chemists refer to as calcium carbonate and assign the formula $CaCO_3$—is an important building material for the houses of human beings, both as a quarry stone or finely ground into a new form. Entire mountains consist of lime, such as the mountain ranges that lie in front of the Central Alps in the north and south of Austria. The prevailing mass of this limestone is biogenic, which means it is produced by living creatures. The fact that such rock masses are the work of ancient sea creatures would hardly be conceivable if we could not now directly observe how gigantic lime accumulations originate in the form of coral reefs. However, these lime reefs are largely defenseless. The animals of the rather simple phylum coelenterate, to which the freely swimming jellyfish also belongs, consist of up to 99 percent water. As a result, they are extremely vulnerable. An enemy's attack is not even necessary; a strong current can tear the creatures apart. Thus a secure shelter is more than important; it is an absolute necessity. Coral polyps create such a shelter for themselves. Other sea inhabitants, like snails and bivalves (two-shelled animals such as mussels), would also be defenseless without the protection of their homes. They would not be as firm and robust without their shells or cases. These creatures belong to the mollusk family, or more specifically to the subphylum of the "shell mollusks." The name says it all.

They build their "mobile homes" themselves with lime precipitations from dedicated body tissue. The snails create one-piece cases and the bivalves, two-piece cases—two flaps linked by an elastic band. The cases of snails and bivalves that please us with their variety of form and rich coloring consist of lime, like coral colonies. The amount of snails, clams, and coral that had to be collected—and over how long a period of time—to give rise to three-foot-thick accumulations is beyond our imagination.

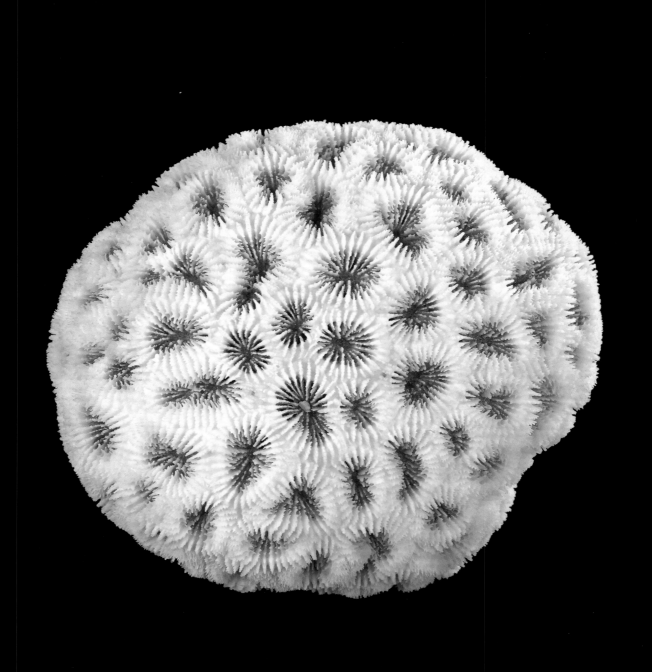

STONY CORAL - SKELETON
(Scleractinia), LIME

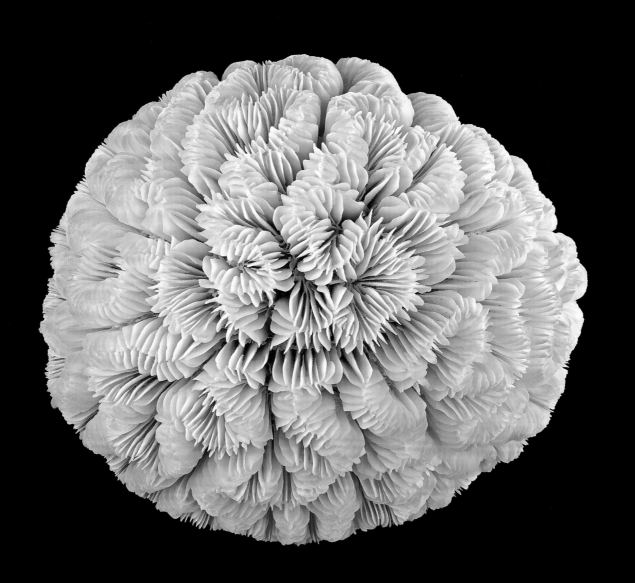

MAZE CORAL - SKELETON
(Meandrina meandrites), LIME

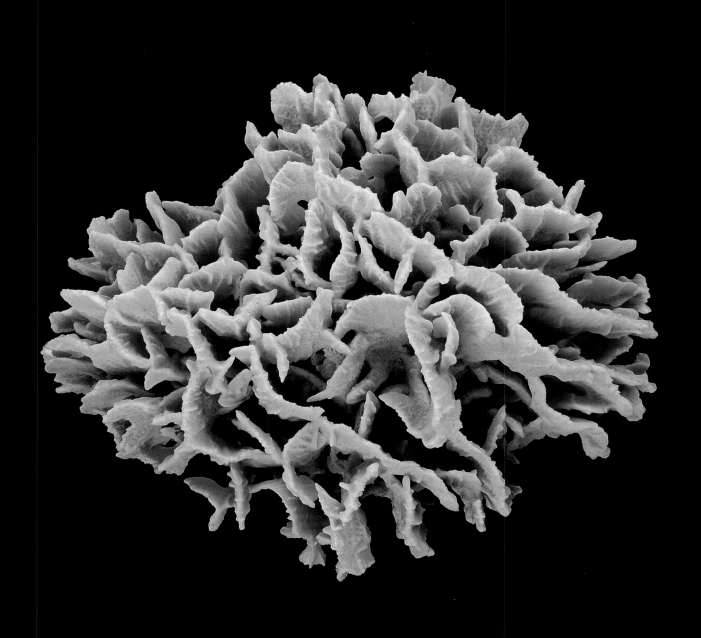

ELEPHANT SKIN CORAL - SKELETON

(Pachyseris sp.), LIME

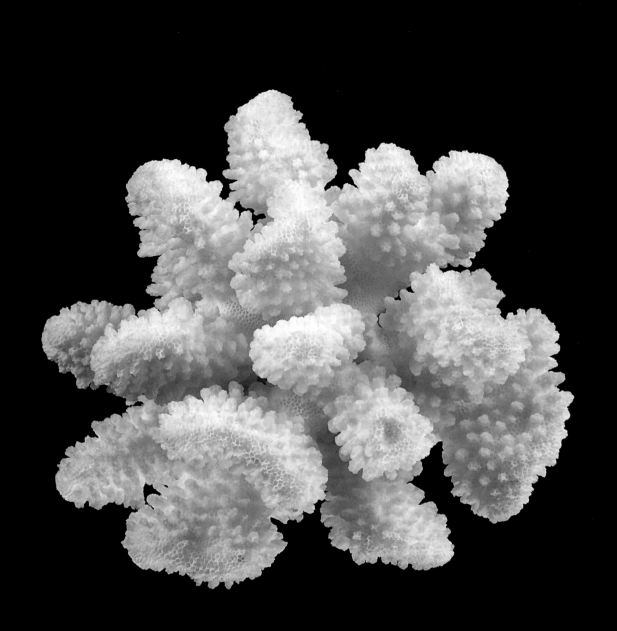

CAULIFLOWER CORAL – SKELETON
(Pocillopora sp.), LIME

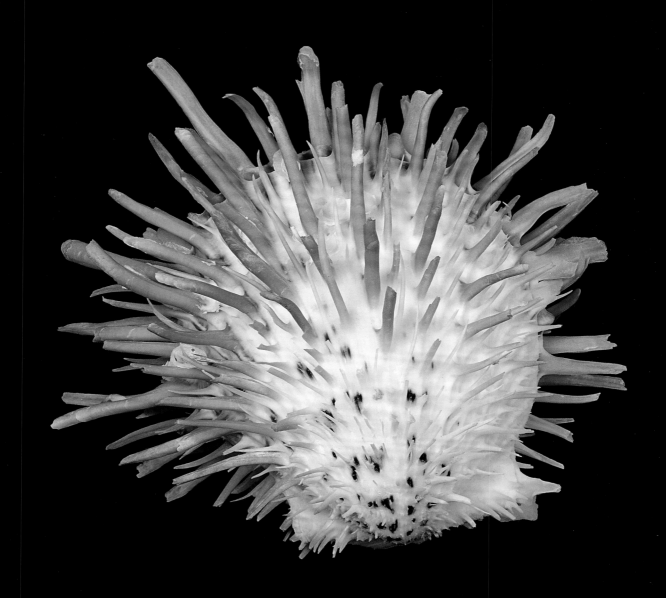

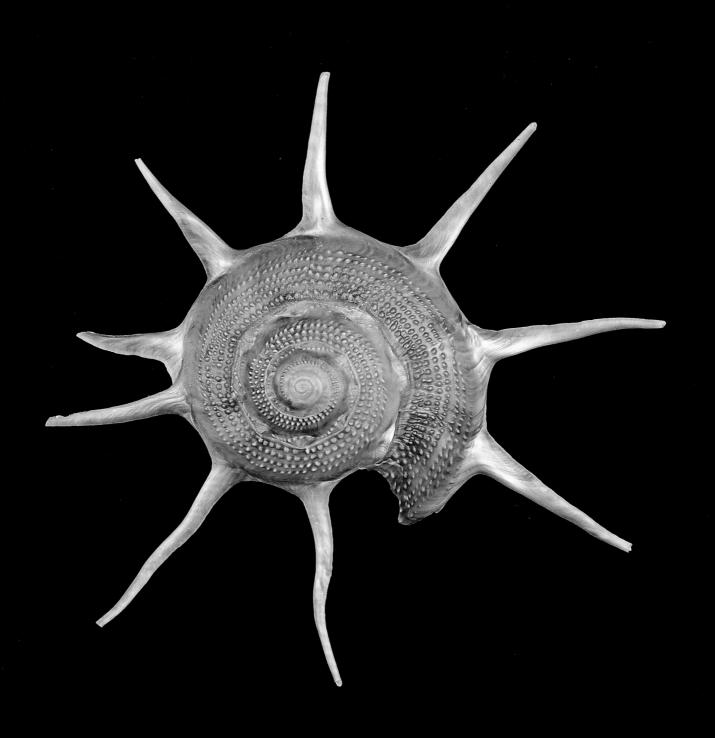

TURBAN SNAIL
LIME

CORALS, BIVALVES, SNAILS *Calcified Master Builders*

Sea organisms have been building their body shells from lime for roughly six hundred million years. Mighty lime sediments many feet thick have originated over this long span of time. Entire mountain ranges consist of the former constructions of sea inhabitants. For the most part, the carbon in the lime comes from the air, while carbon dioxide (CO_2) is taken from the atmosphere and chemically bound in the lime. Today, the creature-generated limestone mountains are the largest carbon store on earth. The lime constructions and lime cases of marine animals have aided in the understanding of evolutionary biology. Fossils were discovered entrapped within various layers of rock, which made it possible to see how the creatures have transformed over the course of millions of years. This provided the impetus for the variability of life forms, and thus, evolution, to be considered for the first time.

If one used the size of an animal's architectural structures as the standard of achievement, then the crown would be granted to limestone coral, despite the fact that the individual builder itself is small and insignificant (coral polyps rarely reach a body height of more than one centimeter). They reproduce by division; the

individual offspring remain connected through shared tissue and organs. As a result, gigantic colonies of several million polyps are created. The polyps mount on the seabed and produce an external skeleton of lime under the base. Thus, they raise themselves slowly upon the growing structure, and this can amount to a few inches in one year, which, when compared to their body height, is quite impressive! If the seabed drops, the coral reefs grow an equal distance upward so that the creatures can continually live in their ideal water depth, which averages around 164 feet (fifty meters). Charles Darwin was the first to come across this phenomenon while questioning why there are coral reefs that can stretch to a depth of several thousand feet, where seemingly no polyp could survive. However, it is actually not the polyps that are so depth limited, but the many species of stony coral living in symbiosis with single-cell algae. Light, required for algae's photosynthesis, decreases quickly with an increasing water depth.

In addition to reproducing by division, the coral creatures can also produce free-swimming larvae that are then carried off by the sea currents. These larvae

ultimately land in various locations, where they origi-nate new colonies in which they live stationary lives like their parents. The skeletons of the stony corals are extremely varied in form and are often of great beauty. This is particularly true of the individual coral underneath the stony corals, since not all of them live in indissoluble, sisterly coexistence like the creators of the reef. If each builds for itself or in smaller colonies, wonderful filigree skeletons come about. The growing skeletons can often branch out and thus form extremely beautiful underwater stone gardens.

Although corals are often noted for their stunning appearance, the cases of snails and the shells of bivalves are also more beautiful than they are usually given credit for. The numerous forms and the colorful patterns on the cases can be admired in many natural history museums. The more than one hundred thousand known snail species require a great deal of display area. This splendor also rouses the collecting zeal of many mollusk enthusiasts. The collection and display of these shells is a great opportunity to expose their intricacies and beauty to the public at large, as long as the regulations for the protection of endangered species are followed. Today, bivalves are represented by approximately only ten thousand species, clearly a much smaller number than the snails. Although their Latin name, Bivalvia, does not sound particularly pretty, it nevertheless aptly describes the two-shell archi-tecture. The two shell halves—composed of lime, and whose most internal layer forms the iridescent mother-of-pearl—are held together at the back by the so-called elastic band (ligament) that pulls the bivalve halves apart and thus allows the creature access to breathe in water and food particles. In contrast, the strong internal sphincters function when the bivalve has had enough of the world and closes its shell. But snails also retreat from the outside world. If they withdraw into their "mobile home" as a last resort, the lime plate that is grown on the upper surface of the foot is often retracted into the precisely fitting shell opening. They are closed for business.

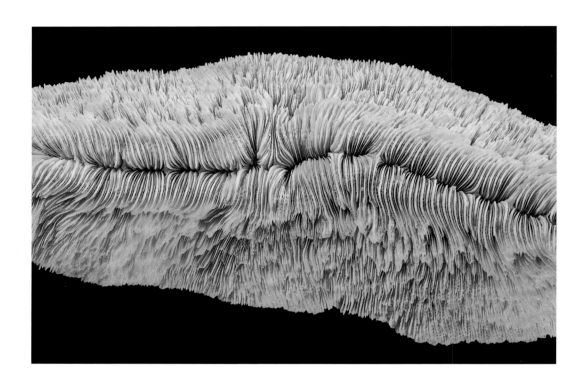

Coral reefs are the largest structures created by living
beings. They consist of colony-forming cnidarians.
The stony corals are best known for generating their
skeletons through the storage of lime and are the
primary species that form coral reefs.

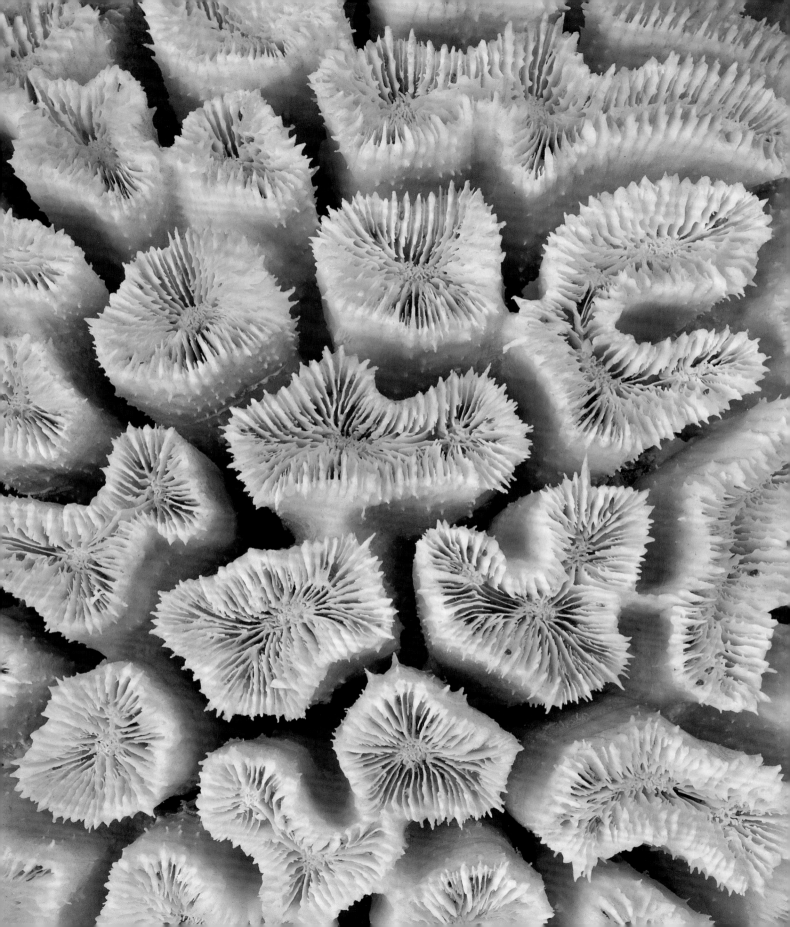

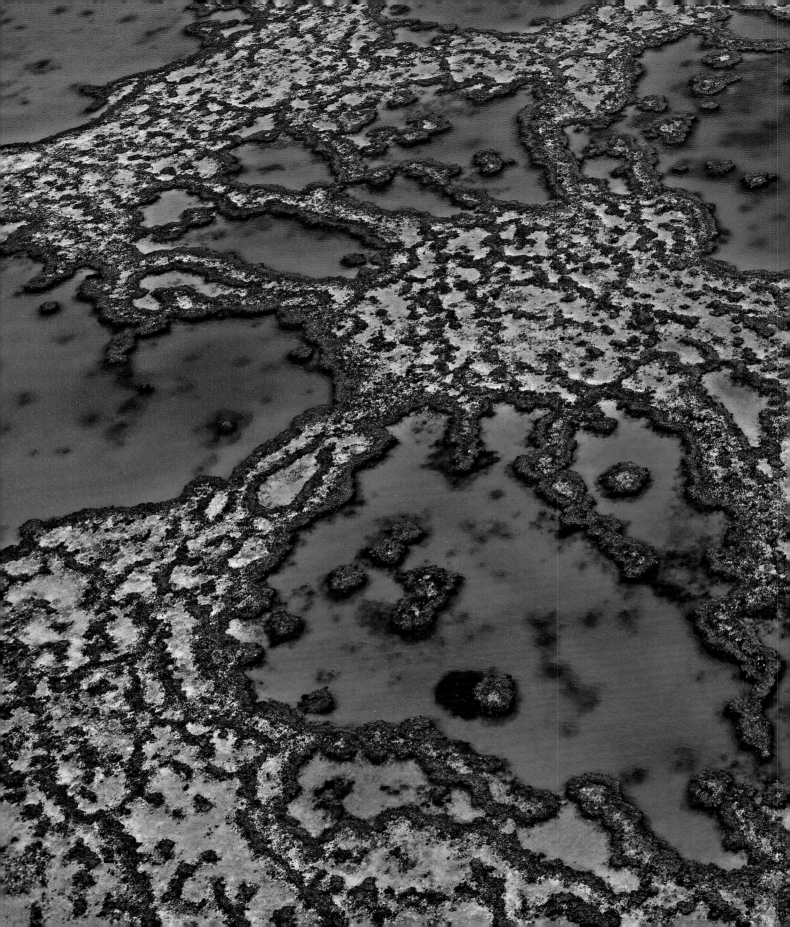

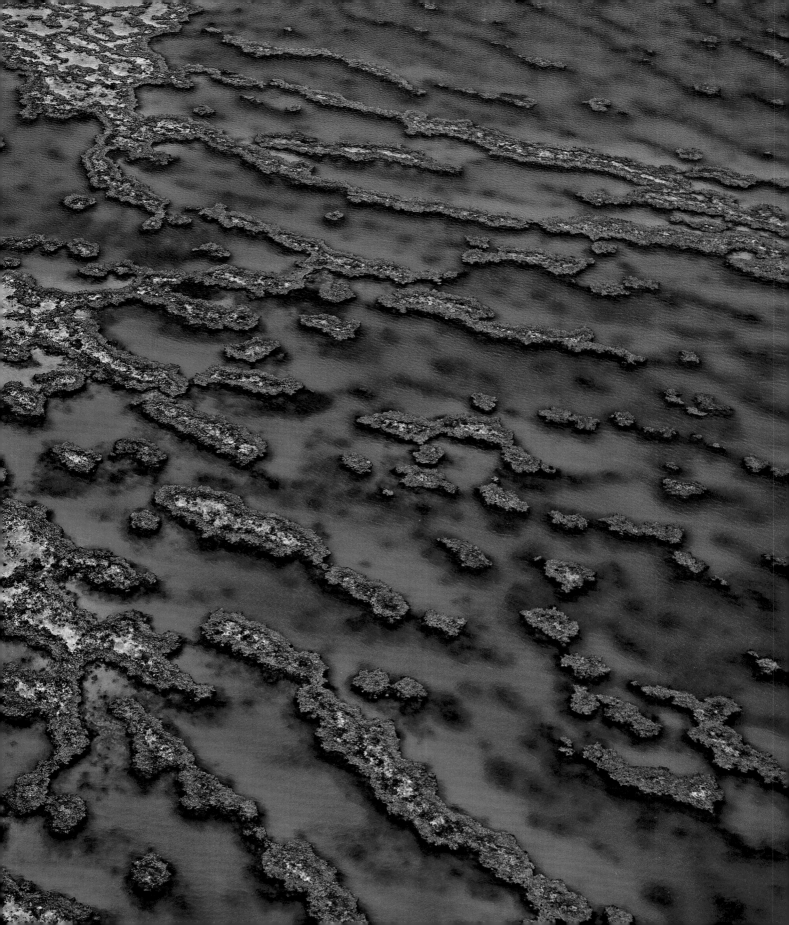

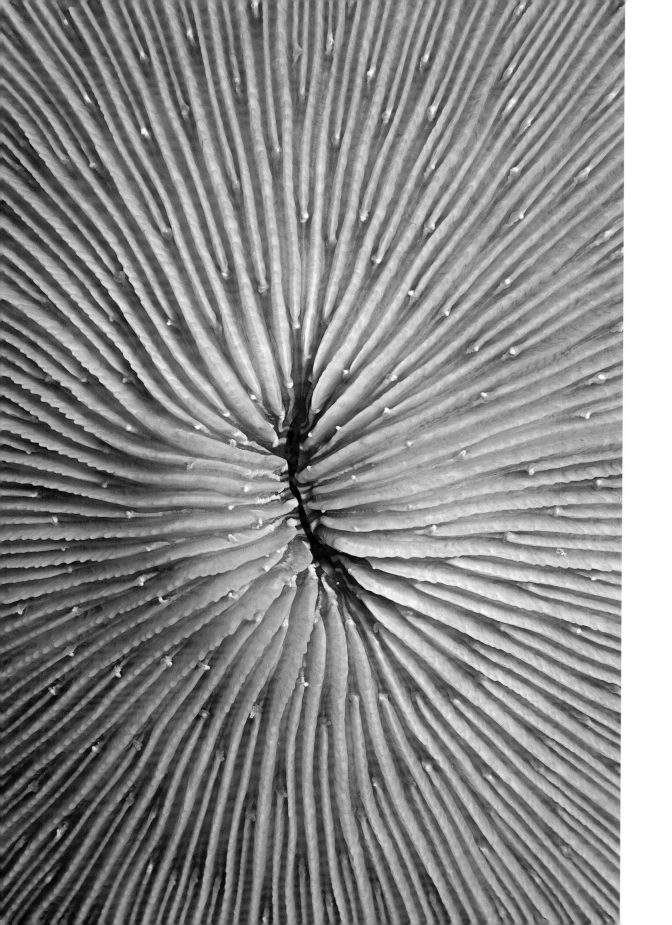

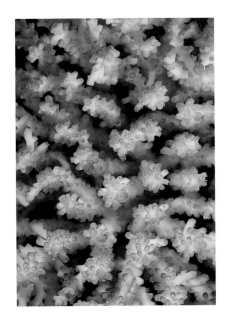 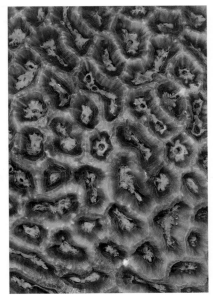 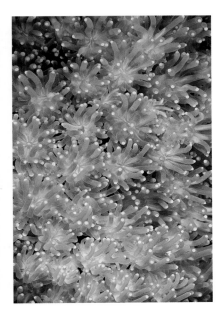

With a surface of approximately 134,000 square miles (347,800 square kilometers), the Great Barrier Reef (see pp. 142–43), situated off the northeast coast of Australia, is the largest coral reef in the world. There are 845 known species among the reef-forming corals. Around one third of them are considered to be imminently threatened by extinction. The rising water temperatures caused by climate change can cause entire reefs to die.

(pp. 146–147)
Even in the exhibits of a museum collection, the corals' multitudes of colors and forms still reveal themselves.

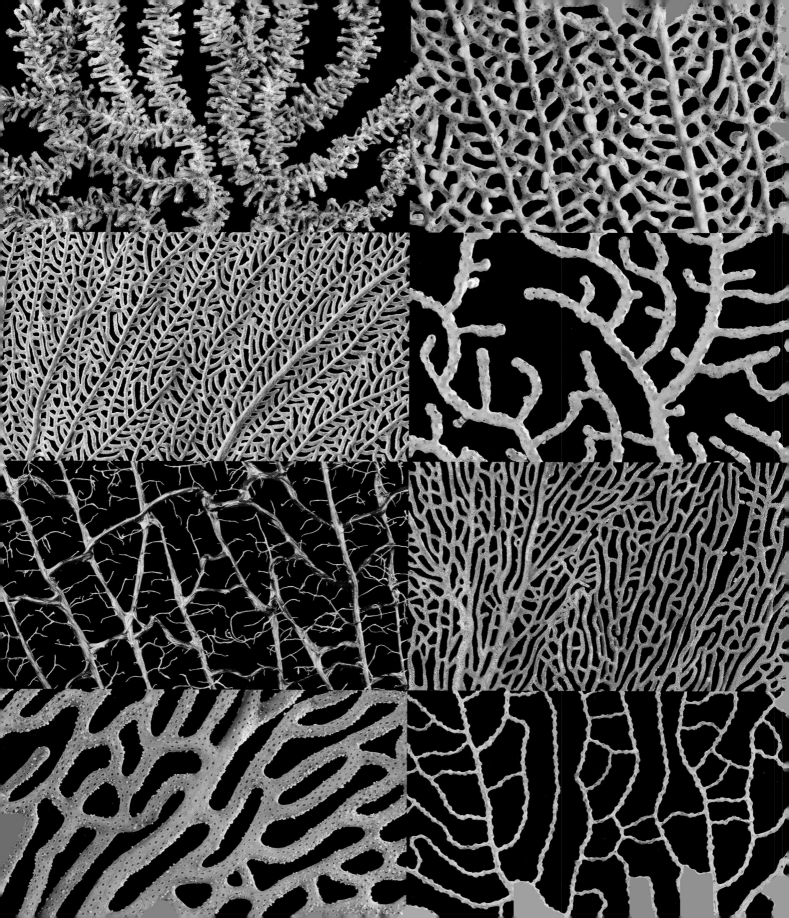

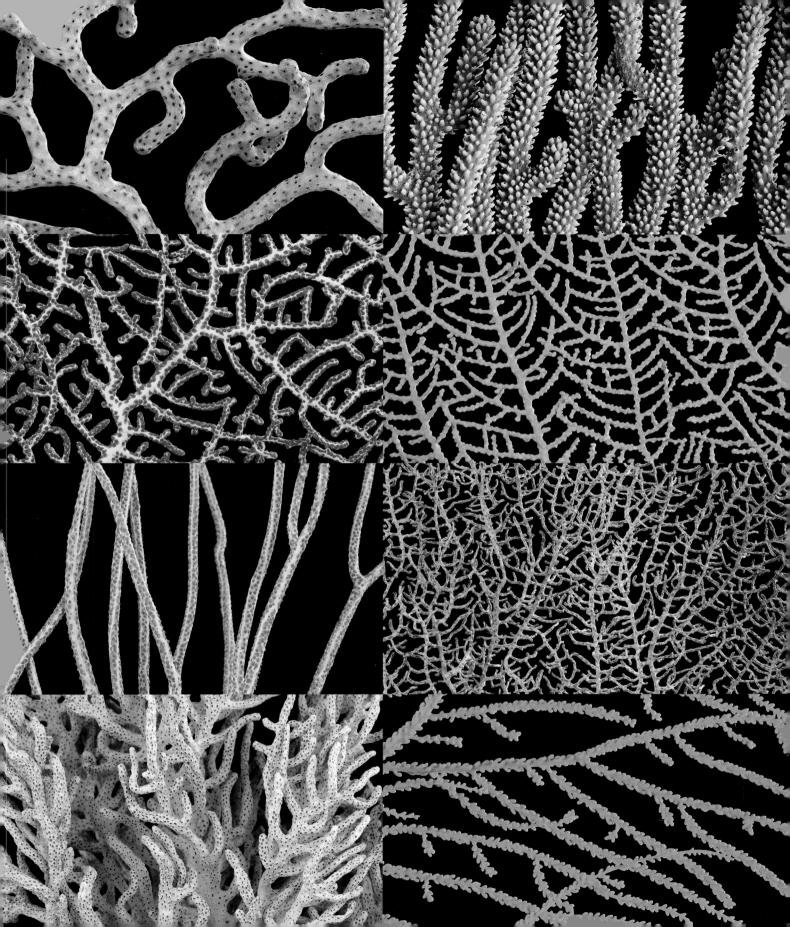

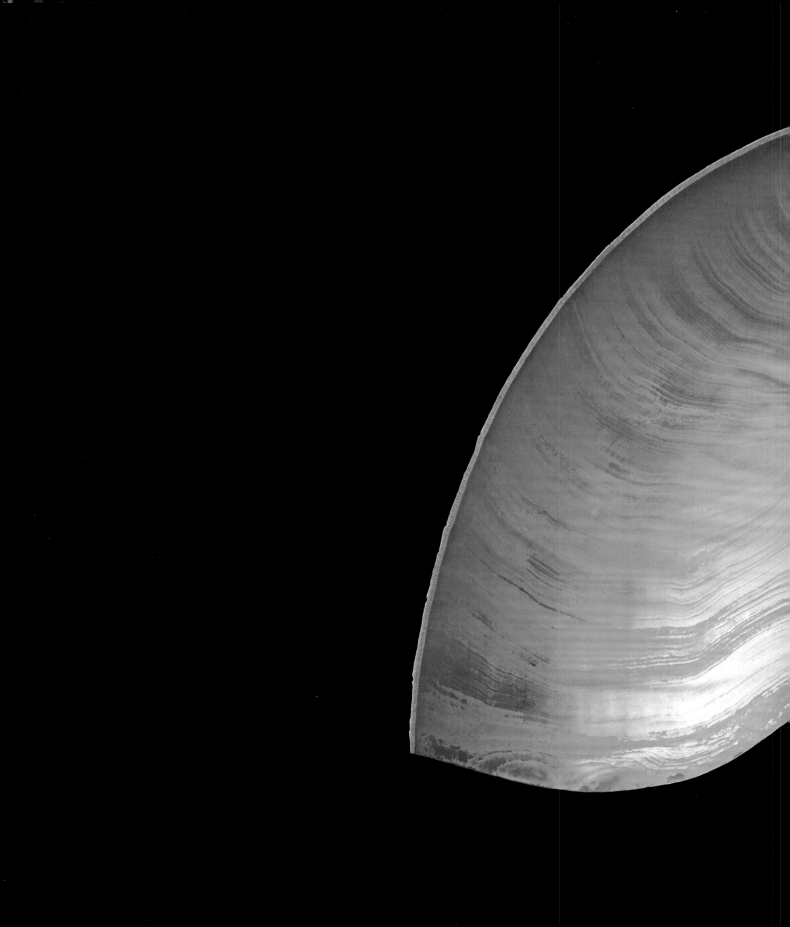

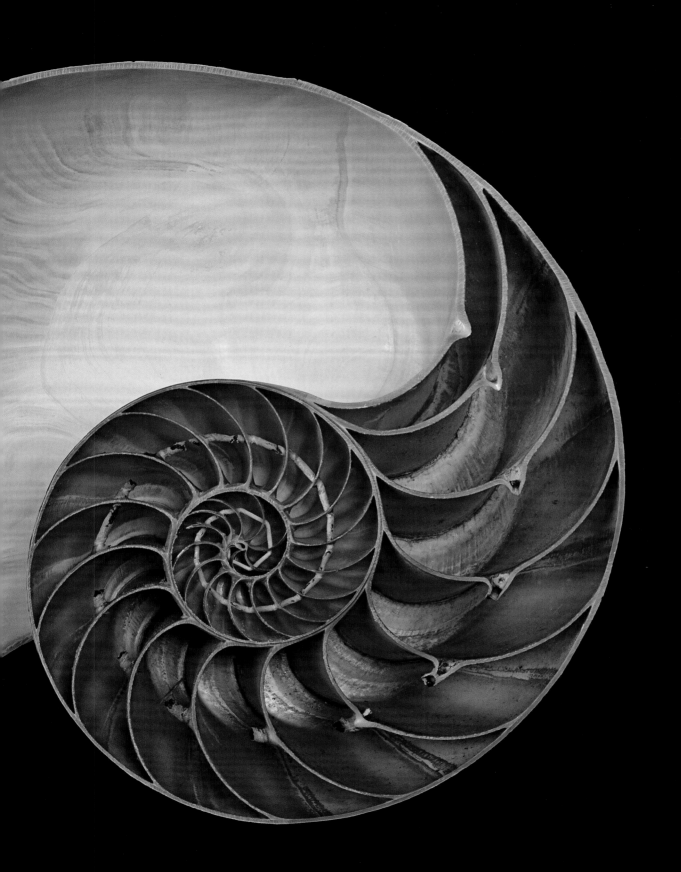

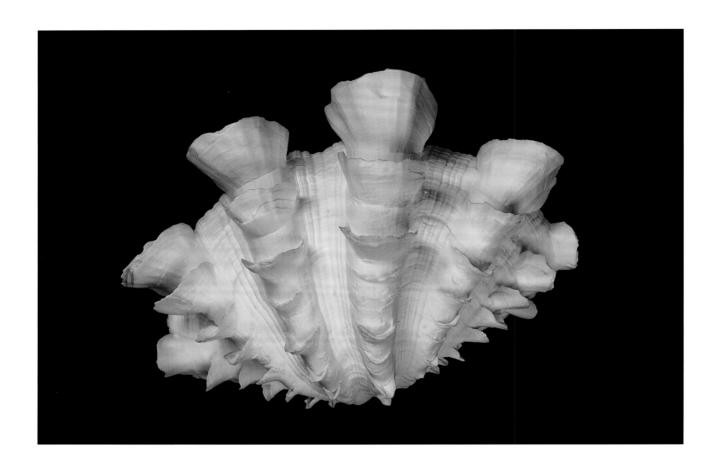

The mussel is a mollusk and protects its very sensitive
body with a case. This protection consists of a left
and a right shell that are held together by an elastic
tape (ligament). Shells, like those of the scaly giant
clam (shown above), primarily consist of lime and are
formed by a skin fold of the mussel itself.

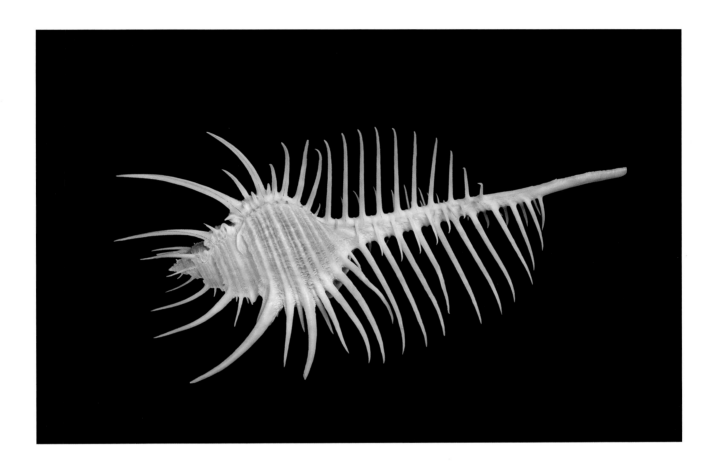

The protective covering of the marine gastropods, or snail housing, also consists of lime and is formed by the snail itself. It clearly differs from the shell of a bivalve through its asymmetrical spiral coil. The housing of the venus comb snail captivates with an extremely filigree form.

(See also the intricate formation of a member of the cephalopod family, the nautilus, pp. 148–49.)

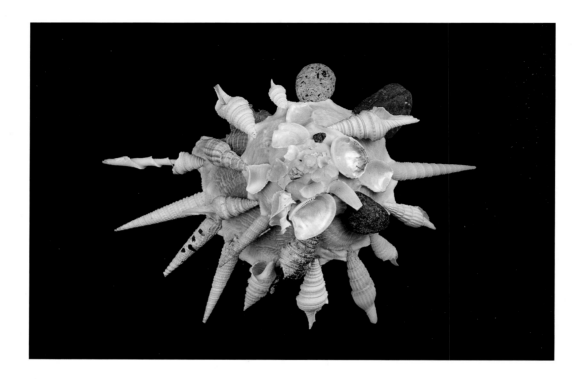

Carrier snails display behavior that is not yet
explained. They collect objects from their surroundings,
primarily pebbles or the shells of other mollusks,
and attach them to their cases. The mounting of an
object can take as long as ten hours and occurs with
the help of bonding secretions from the mantle rim
of the snail.

(p. 153)
The shell of the wentletrap snail fascinates with its
aesthetically pleasing architecture.

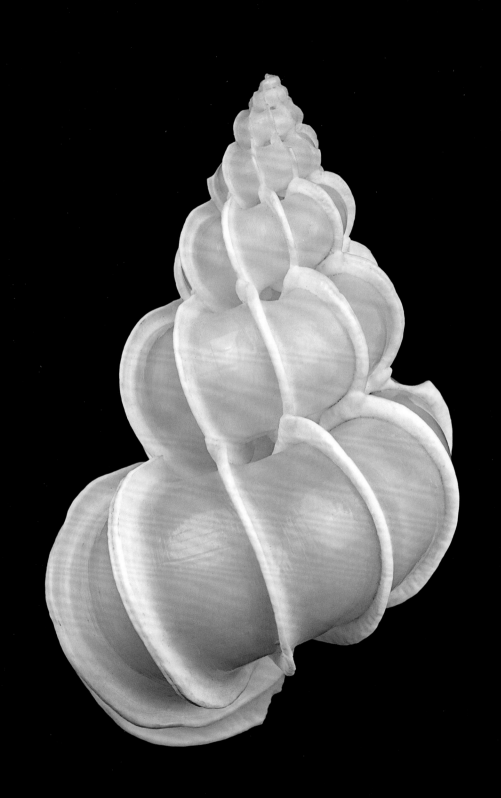

5

INGO ARNDT

AUTHOR'S NOTE ON THE PHOTOGRAPHY

THE GREAT CHALLENGE EXISTED NOT ONLY IN PHOTOGRAPHING THE CREATURES, BUT ALSO IN PLACING THEIR CONSTRUCTIONS IN THE FOREGROUND

Realizing a photo project on the subject of "animal architecture" was an extremely appealing matter. Because I have never committed myself to a specific subject in my work as a wildlife photographer, but rather love the variety in the choice of motifs, this project was right up my alley, so to speak. The great challenge existed not only in photographing the different species, but also in placing their constructions in the foreground. In order to meet the highest of aesthetic standards, I decided to photograph a portion of the subjects detached from their environment and in the studio in front of a black background. I hoped that these studio shots, in combination with the subjects that often come into being under extreme conditions out in nature, would provide the right mix for this topic. From the red ants just outside my front door over to the bowerbirds in the remote jungles of West Papua and up to the huge termite fields in hot, northern Australia, I have traveled around the globe photographing animal architects. I was on the road by foot, in mobile homes, in all-terrain vehicles, helicopters, and planes. No matter what the corner of the world, I was deeply impressed by the various constructions and the creativity of the animal architects I found there. It was difficult to imagine what artistic constructions can be created by a tiny insect larva or how a rodent manages to mold an entire landscape to its advantage. The different themes and locations required various combinations of photographic equipment. For the technologically minded, here are some comments:

Only cameras and lenses made by Canon were used for this project. The cameras I trusted were the EOS-1Ds Mark III and EOS-1D Mark IV housings. I used lenses with focal lengths from 14 to 500 mm. A solid tripod made by Gitzo was always in tow. Also alongside were a plethora of smaller pieces, from an electric shutter to an underwater housing. For the work in the studio, I used a large flash attachment and tinkered with the various tools available so that the objects appeared to be free-floating in front of the background. The equipment was transported in waterproof backpacks from David King & Co.

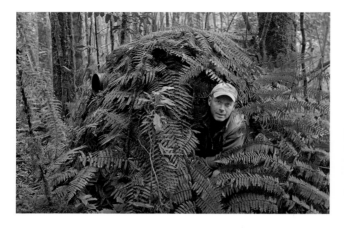

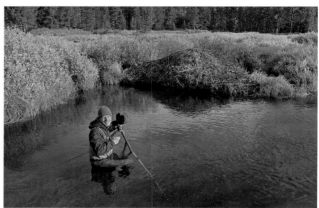

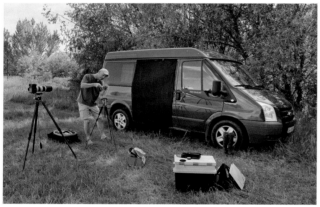

A well-disguised hiding place was necessary to take a photo of the bowerbirds in the rain forest of the Arfak Mountains in West Papua (top left).

The best place to take pictures of a beaver lodge in Yellowstone National Park is in the middle of the beaver pond (top right).

A photo of a harvest mouse's nest also can be taken under studio conditions in the open land. During this process, the camper served as a fixture for the black fabric background (bottom left).

With a small balancing act, it was possible to photograph baya weavers at eye level in Singapore (right).

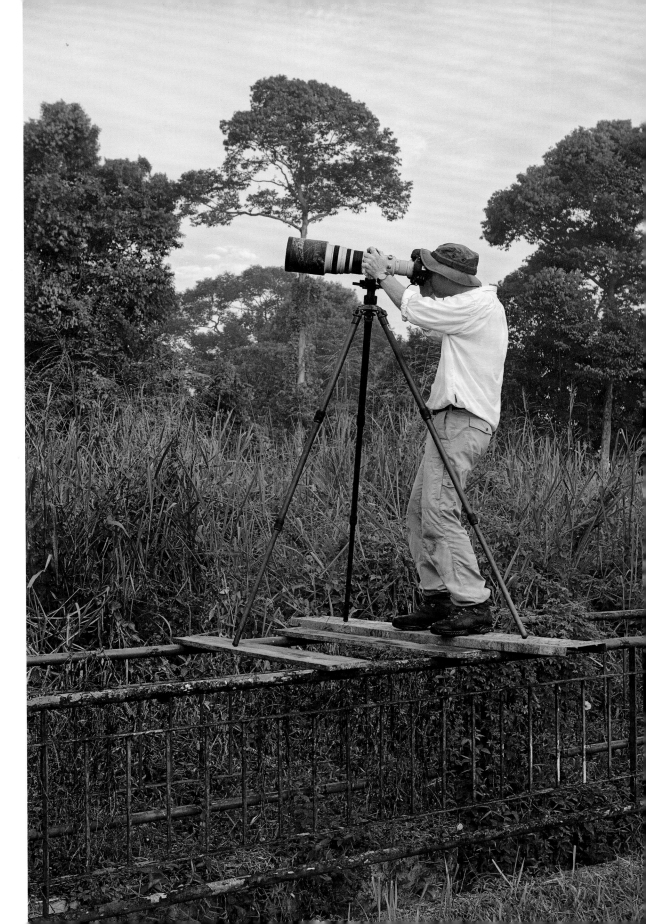

BIBLIOGRAPHY

Dawkins, Richard. *The Extended Phenotype: The Long Reach of the Gene.*
New York: Oxford University Press, 1999.

Hansell, Mike. *Built by Animals.*
New York: Oxford University Press, 2007.

Mayr, Ernst. *Das ist Evolution.*
Munich: Goldmann Verlag, 2005.

Tautz, Jürgen. *Phänomen Honigbiene.*
Heidelberg: Spektrum-Elsevier, 2007.

Turner, Scott J. *The Extended Organism: The Physiology of Animal-Built Structures.*
Cambridge, MA: Harvard University Press, 2002.

Von Frisch, Karl. *Tiere als Baumeister.*
Berlin: Ullstein Verlag, 1974.

Wilson, Edward O. *The Insect Societies.*
Cambridge, MA: Harvard University Press, 1971.

Zahner, Volker, Markus Schmidbauer, Gerhard Schwab. *Der Biber: Die Rückkehr der Burgherren.*
Amberg: Buch & Kunstverlag Oberpfalz, 2005.

ACKNOWLEDGMENTS

An extensive project such as *Animal Architecture* requires the help and support of many people.

For their assistance during the photographic work, I would like to thank the following people and institutions: Hildegard Adamczyk, Stefan Bosch, Matthias Fehlow, Wolfgang Henning, Paul Hien, Ute Heek, Werner Horn, Jianzhong Liu, Jörg Müller, Martin Päckert, Shita Prativi, Irmgard Schultheis, Andrea Sundermann, Gerhard Schwab, Peter Tauchert, Jürgen Tautz, Zeth Wonggor, and Frederike Woog.

Meeresmuseum Ozeania, Riedenburg; Senckenberg Naturmuseum, Frankfurt; Staatliches Museum für Naturkunde, Stuttgart; Überseemuseum, Bremen; Zoo Basel.

Representative of the support of the editorial teams, I thank: Antonia Bürger, Susanne Caesar, Maria Platte, and Fabian Arnet with the Knesebeck Verlag; Peter-Matthias Gaede, Ruth Eichhorn, and Venita Kaleps with GEO.

Above all, I thank my wife, Silke Arndt. She has again wonderfully designed this book, has accompanied me on many trips with a video camera, and has maintained the work in the office when I was on the move alone.

Ingo Arndt

Designer: Silke Arndt, Langen
Production: VerlagsService Dr. Helmut Neuberger &
Karl Schaumann GmbH, Heimstetten
Lithography: Reproline Genceller, Munich

English-language Edition:
Editor: Samantha Weiner
Cover Design: Sebit Min
Production Manager: Erin Vandeveer

Library of Congress Control Number: 2013945498
ISBN: 978-1-4197-1165-7

Copyright © 2013 Knesebeck & Co. Verlag KG, Munich
A company of the La Martiniere Group
English translation copyright © 2013 Abrams, New York

All photographs in this book © Ingo Arndt, Langen,
www.ingoarndt.com
With the exception of pages 156–157 © Silke Arndt
The photographs in this book were neither digitally
altered nor manipulated.

Title, layout, typesetting © Silke Arndt, Langen
Foreword © Jim Brandenburg
Chapter introductions: Prof. Dr. Jürgen Tautz
Photo captioning: Ingo Arndt

Printed and bound in China
10 9 8 7 6 5 4 3 2 1

Abrams books are available at special discounts when
purchased in quantity for premiums and promotions as
well as fundraising or educational use. Special editions
can also be created to specification. For details, contact
specialsales@abramsbooks.com or the address below.

115 West 18th Street
New York, NY 10011
www.abramsbooks.com